IMAGES
of America

MEIGS COUNTY

IMAGES
of America

MEIGS COUNTY

Jordan D. Pickens and Ivan M. Tribe

ARCADIA
PUBLISHING

Published by Arcadia Publishing
Charleston, South Carolina

Printed in the United States of America

Library of Congress Control Number: 2013943911

For all general information, please contact Arcadia Publishing:
Telephone 843-853-2070
Fax 843-853-0044
E-mail sales@arcadiapublishing.com
For customer service and orders:
Toll-Free 1-888-313-2665

Visit us on the Internet at www.arcadiapublishing.com

*We dedicate this book to everyone who has
ever called Meigs County home.*

CONTENTS

ACKNOWLEDGMENTS

Without several people and organizations, this book would not be possible. First, we would like to thank Robert Graham for allowing us into what is arguably the largest private collection of Meigs County pictures and artifacts. Second, the Meigs County Historical Society has contributed extensively to this project by lending pictures, as well as providing us a place to work. Third, a thank-you goes to the *Daily Sentinel* for allowing us into its archives and while putting this book together permitting us to keep any pictures we chose. Lastly, we would like to thank our wives, Deanna Tribe and Calee Pickens, for their contributions of pictures, assisting in creating captions, and for their love and support.

Several people contributed to the development of this book. We owe a debt of gratitude to Fred Werry for the iconic 1913 flood image found on the cover. Others who supplied photographs, information, or technical assistance include Keith Ashley, Jake Bapst, Robert and Jane Beegle, John Bentley, Gary Coleman, Mary Stobart Cowdery, James Dalton, Eli and Velessa Fink, Tom and Judy Gannaway, Darla Garvin, Jimmie Hobbs, Charlene Hoeflich, Walter Jordan, Brenda Loucks, Charlie Mankin, Sandra Covert Manson, Waid Nicholson, Jill Nunn, Margaret Parker, Mary Pickens, Eber Pickens Jr., Harley Pickett III, John Powell, Charley Pyles, Bob and Margie Reeves, Bryan and Susan Reeves, John Riebel, Frank and Ann Ryther, Mary Margaret Schley, Rick Thomas, Roger Van Dyke, Debbie Garnes Ward, Charles Withee, and Peggy Yost.

Those who wish to learn more about the history of Meigs County may consult the Meigs County chapter in Henry Howe's *Historical Collection of Ohio* (1888), the Meigs County portion by James M. Evans in *Hardesty's Historical and Geographical Encyclopedia* (1883), Edgar Ervin's *Pioneer History of Meigs County, Ohio* (1949), and the three volumes of family history in *Meigs County, Ohio* (1979, 1987, 2001) by the Meigs County Pioneer and Historical Society, Inc.

INTRODUCTION

In the mid-20th century, a regional newspaper published in a nearby county featured a column in its Meigs County section titled Where the River Bends. The phrase is relevant because the Ohio River, as it borders much of the county, flows in every direction but east and for a few miles veers in a northeasterly direction. The landscape varies from a flat, fertile river bottom to fairly steep hills, but it can be described overall as gently rolling hills.

Early European travelers took special note of rapids named initially by the French but then Anglicized to Letart, which was later largely obliterated by the lock-and-dam system. In 1787, the land that included all of Meigs County became part of a large tract purchased from the Confederation Congress by the Ohio Company of Associates, a New England concern led by such luminaries as Manassah Cutler, Rufus Putnam, and Benjamin Tupper. Among the residents of their principal settlement, Marietta, a minor stockholder named Return J. Meigs had a son named Return J. Meigs Jr. (1764–1825), who became an early governor of Ohio (1810–1814). In April 1819, when the legislature created a new county at the expense of Gallia and a majority of Athens, it received the name of the former governor. The 1820 Census shows that 4,480 persons resided in Meigs County.

Over the next 50 years, the county's population increased sevenfold. A mid-19th-century estimate showed that 39 percent of residents had come from the Mid-Atlantic region while another 26 percent hailed from the South (chiefly Virginia). Only 10 percent of inhabitants hailed from New England, although they seemed more influential than their actual numbers indicated (a characteristic of all the Ohio Company counties). Nearly a quarter of the populace was foreign-born; these people were chiefly Germans but also included some Welsh. In addition, many of those from the Mid-Atlantic and Southern states tended to be second-generation Americans whose parents emigrated from the German Palatinate from 1730 to 1755. Thus, Meigs County benefited from two waves of German migrations, each a century apart. Other residents hailed from Scottish or Irish stock. By 1860, some 26,534 persons called Meigs County home, a total that exceeded any neighboring county.

Middleport, halfway between Pittsburgh and Cincinnati, served as the temporary county seat until 1822, when the newly platted inland hamlet of Chester became the center of government. A courthouse stood on a hill overlooking a public square (or commons), surrounded by building lots. After 19 years, the county seat moved again to Pomeroy, where it has since remained. Middleport continued to rival Pomeroy as the largest town in the county, while Racine, Rutland, and Syracuse attained some significance as smaller villages. Such communities as Chester, Harrisonville, Reedsville, and Tuppers Plains remained local market centers, with the latter growing larger in recent decades. The Civil War had a major impact on Meigs County, as nearly 10 percent of its total population served in the Union army; over 500 residents made the supreme sacrifice. The only real battle fought in Ohio was at Buffington Island, near Portland. Union forces gathered to successfully thwart Confederate cavalry raider John Hunt Morgan's forces from crossing back

across the Ohio River. Reenactments of this battle are still held today. Meigs County residents provided solid moral support for West Virginia when it joined the Union during the Civil War.

Minerals played a role in economic development, as demand for coal and salt found markets downriver in such growing urban centers as Cincinnati and Louisville. With the coming of the Ohio Central Railroad and Hocking Valley Railway in the early 1880s (and their corporate successors), north-south transit began to rival the river as an artery of commerce. Links to Charleston, Columbus, Toledo, and Detroit opened up for Meigs County residents and products. Newer small communities such as Carpenter, Dyesville, and Dexter began to appear on the map. Hobson, a tiny community today, became a division point on the rail line, and the adjacent Hobson Yard provided dozens, if not hundreds, of jobs for local men.

In raw numbers, Meigs County's overall population began to slowly decline after an 1880 peak of 32,325. As local historian James Evans phrased it, "The cause of this decrease being the immigration to the states west of the Mississippi river of young men anxious for adventure, and for essaying their fortunes in new and promising fields." Letters to the editors of local newspapers tell of former residents in such agricultural states as Iowa, Kansas, Missouri, and Nebraska; less frequent are epistles from farther west. After 1900, the attraction of manufacturing jobs in Midwestern cities lured even more people as agricultural activity began to decline on less favorable and increasingly less productive hilly land. Except for a slight upward bump during the Great Depression when younger unemployed workers came back home, the downward dip bottomed out in 1970, when only 19,770 persons claimed the county as home. The opening of new coal mines that supplied power plants in the 1970s resulted in expanded economic activity. Growth in the last four decades has stabilized the population in the range of 22,000 to 23,000 people.

Meigs County folks have made their marks in the world at large. The county has been called home to two members of the US Congress, a western cattle king, and nine major-league baseball players (four of whom had substantial careers), as well as noted football and basketball players and coaches.

New high schools, renewed emphasis on tourism with numerous festival-like events, more diversity, increased access to higher education, renewed emphasis on local arts, new Ohio River bridges, and improved highway connections have provided a new lease on life for the resilient people of Meigs County. Old traditions and community spirit continue as before, and it all points to a past with pride and to the future with optimism.

One

VILLAGES AND
COMMUNITIES
POMEROY, MIDDLEPORT, AND OTHERS

While Meigs County has never had any cities, it can boast five incorporated villages; of these, Pomeroy and Middleport are much larger. Pomeroy, the county seat, has a long frontage along the Ohio River with many retail establishments, mostly on the side of the street facing the river. There is a large parking lot between the street and river. Through the late 19th century and much of the 20th century, Elberfeld's Department Store dominated retail trade, along with the smaller Red Anchor Store and other shops. The town has also had its share of watering holes, bearing such colorful names as the Green Lantern and the Dew Drop Inn. Middleport's business district has about three blocks on both sides of the street. Retail business has declined in recent decades, although in 2010 Middleport led in residents, with 2,530 to Pomeroy's 1,852. Ironically, at the onset of the Great Depression, both numbered their populations in the range of 3,500 to 3,600 people.

Of the smaller villages, only Rutland is inland, while Syracuse and Racine are upstream but south of Pomeroy. Rutland, with its name of New England origin, had the county's first post office in 1813 and served as an early center of the Free Will Baptist movement. Syracuse once claimed a school of higher learning in Carleton College, whose chief benefactor, Isaac Carleton, was known for his support of education of former slaves (but apparently not at Carleton). Syracuse, less enthusiastic with Carleton's ideas, was known as a "sundown town," meaning an all-white community. It is the subject of a chapter in a century-old sociological study, *The Color Line in Ohio*. Racine took great pride in its basketball teams and the truck-farming areas of river bottomlands. In recent years, some of the growth in these incorporated villages has been just outside town limits.

Among the unincorporated communities, former county seat Chester and Tuppers Plains are large enough to be incorporated, with the latter increasingly becoming an exurb of Parkersburg, West Virginia. Harrisonville once had a high school, but in recent decades it has only a few houses, a flourishing Masonic lodge, and a Presbyterian church. Carpenter and Dexter languished with the demise of passenger trains in 1951.

In 1898, Meigs County had 53 post offices, many of them in tiny communities; a few may have been in private homes. With the advent of rural free delivery, church and school consolidations, and EPA regulation of gasoline tanks that put many mom-and-pop gas stations out of business, these are fading from the landscape.

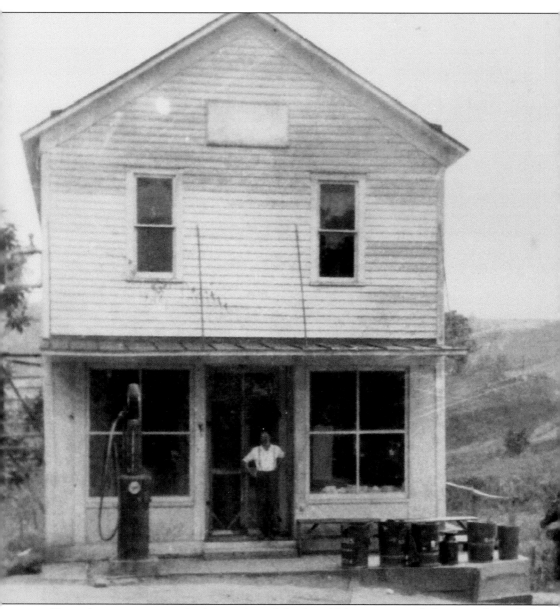

General stores were a major innovation of the late 19th century, and they transformed the business of retailing in the United States. Robinson's general store provided the people of and around Alfred with everything from dry goods and shoes to food and fuel. (Courtesy of Meigs County Historical Society.)

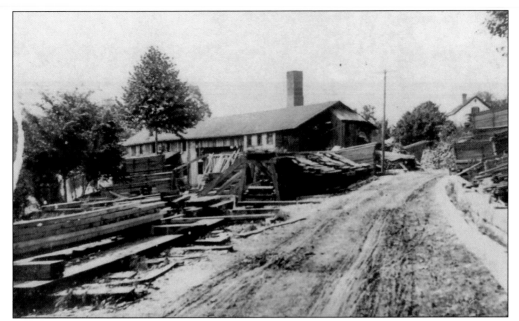

The Riverside Mill, also known as the Antiquity Mill, was owned and operated R.M. Coe from as early as 1893 to the 1920s. Most of the wood cut here went into building many of the houses and businesses in Racine, Letart, and Apple Grove. (Courtesy of Robert Graham.)

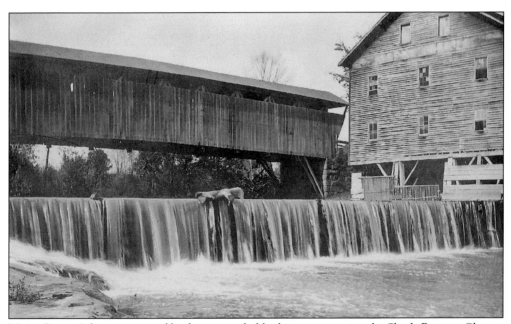

Meigs County's longest covered bridge was probably this one spanning the Shade River at Chester that preceded the later concrete one on Route 248. Alongside the bridge was the Chester flour mill. The Shade River was dammed to allow the mill to operate. (Courtesy of Robert Graham.)

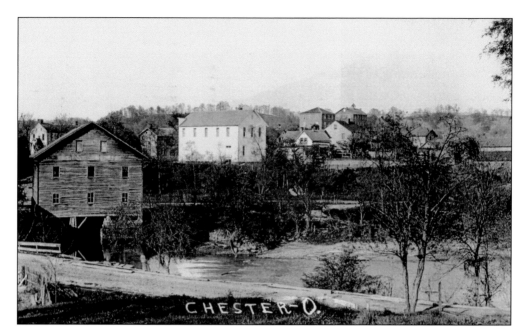

In the image above, the view is looking at Chester. From 1823 until 1841, when the county seat was moved to Pomeroy, the Chester Courthouse, pictured below, stood on the hill overlooking the village commons (or square). In the 1990s, the Chester-Shade Historical Association set about restoring both the original courthouse and the Chester Academy. (Both, courtesy of Meigs County Historical Society.)

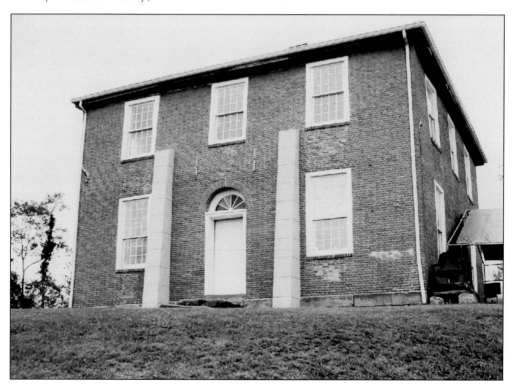

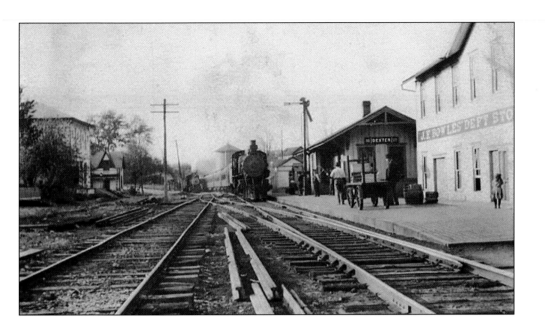

This photograph from the early 1900s shows a southbound passenger train pulling into Dexter with the Independent Order of Odd Fellows hall on the left and the Dexter Depot and the J.F. Bowles Mercantile Company on the right side of the tracks. J.F. Bowles (below) sold furniture, clothing, stoves, stoneware, horse harnesses, and hardware. (Above, courtesy of Waid Nicholson; below, courtesy of Robert Graham.)

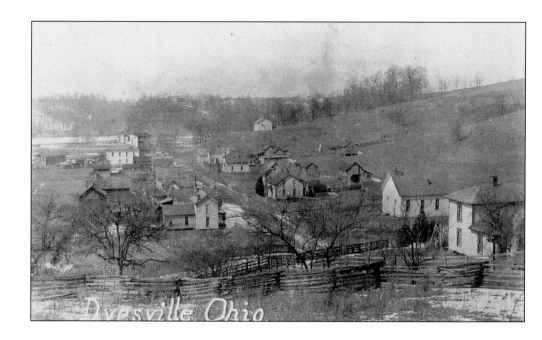

The community of Dyesville in southern Columbia Township owed its existence to the railroad. At times, it boasted a post office, depot, general store, flour mill, blacksmith shop, Knights of Pythias lodge, and Methodist Protestant church. Only Dyesville Community Church, a few dwellings, and railroad tracks without a depot or stop remain today. The photograph below dates to 1960. (Above, courtesy of Robert Graham; below, courtesy of Ivan Tribe.)

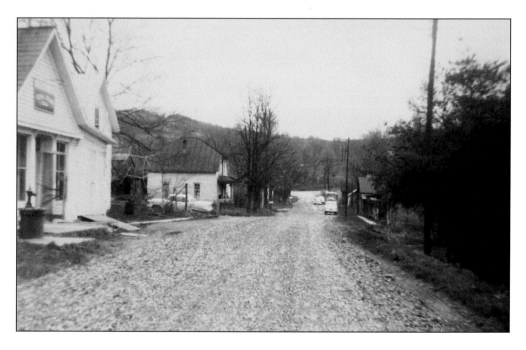

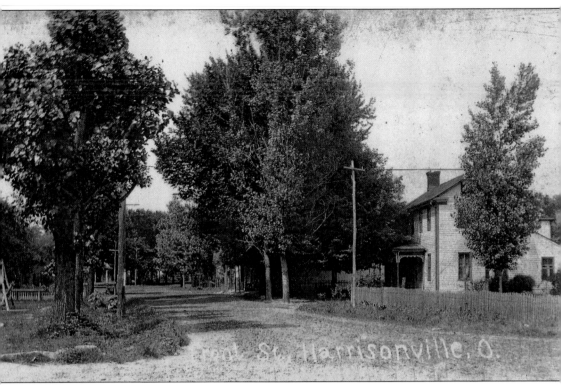

Harrisonville was laid out in 1840 during the presidential campaign of William Henry Harrison and is so named after him. This is a c. 1910 photograph of what is now the intersection of Route 684 and Route 143. (Courtesy of Jordan Pickens.)

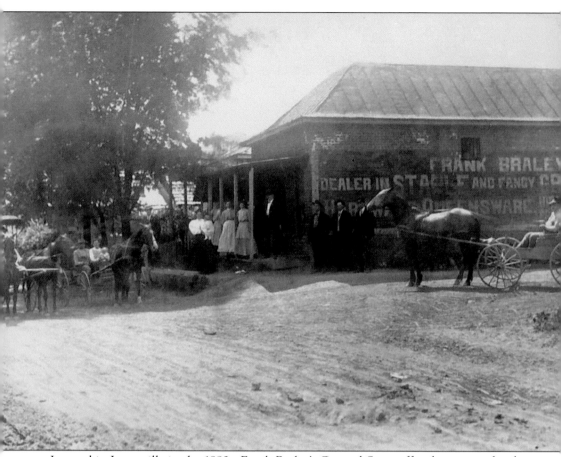

Located in Langsville in the 1880s, Frank Braley's General Store offered groceries, hardware, and various other items. Here, several people pause for a photograph outside the establishment in their Sunday best, along with their horses and buggies. (Courtesy of Meigs County Historical Society.)

The Tyro Mill in the Letart area was built and operated by Tobias and H.M. Alexander, a father and son respectively. They sold their own brand of Little Princess flour. The mill burned in November 1926 and was never replaced. (Courtesy of Jordan Pickens.)

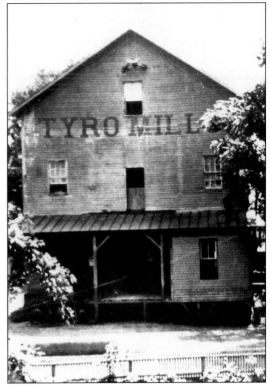

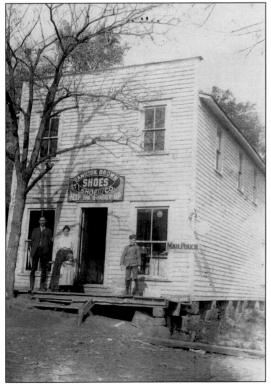

A.F. Swan, pictured here with his wife and children, sold everything from Brown Shoes to Mail Pouch Chewing Tobacco. The Long Bottom store operated from 1893 to 1910, when it was torn down to widen the state road. (Courtesy of Robert Graham.)

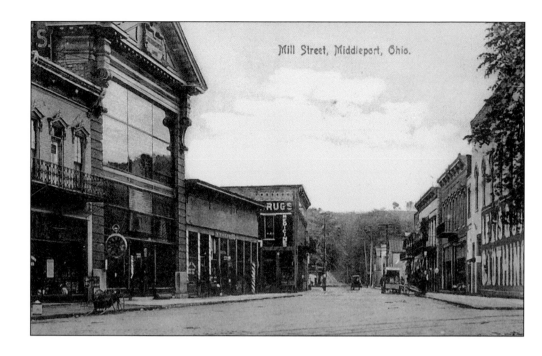

Mill Street, Middleport, Ohio.

Founded around 1820 as Sheffield, Middleport earned its name from being geographically located as the middle port on the Ohio River between Pittsburgh and Cincinnati. Shown here are Mill Street and Second Street in the mid-1910s. (Both, courtesy of Meigs County Historical Society.)

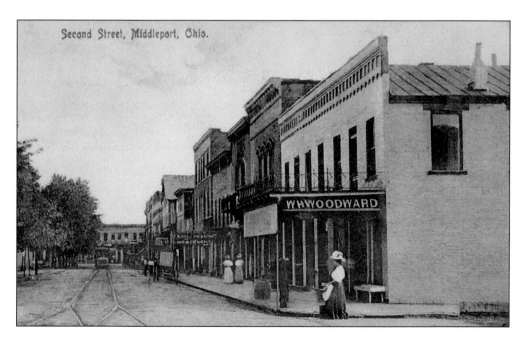

Second Street, Middleport, Ohio.

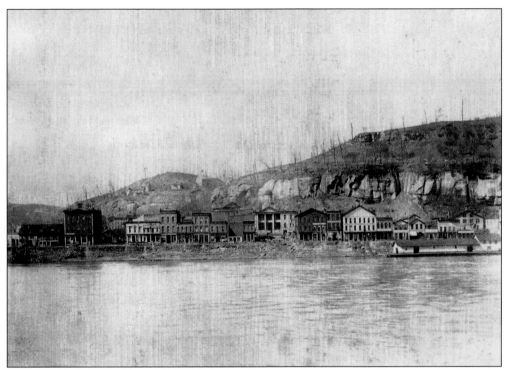

Pomeroy's first resident dates back to 1806 in the area of what is now Kerr's Run. In 1830, the town's namesake, Samuel Willys Pomeroy, arrived in the village and claimed that "the area is a good and healthy place to live." The county seat is featured twice in *Ripley's Believe It or Not*: the three-story Meigs County Courthouse in downtown Pomeroy, which has a ground-level entrance on every floor, and because of the community's lack of cross streets. The business district is in the National Register of Historic Places. (Both, courtesy of Robert Graham.)

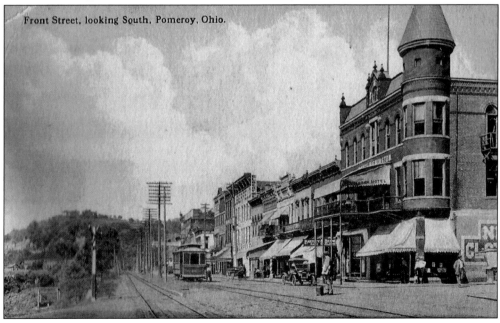

Front Street, looking South, Pomeroy, Ohio.

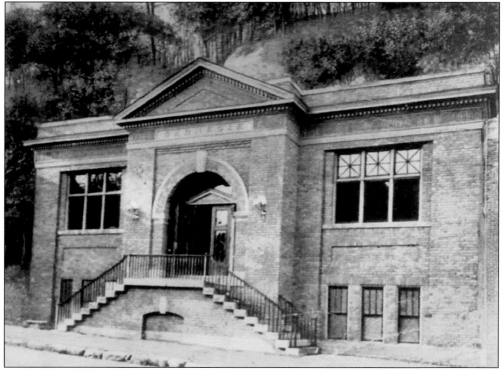

In the early 1900s, Carnegie libraries, started by business tycoon and philanthropist Andrew Carnegie, encouraged small towns to raise 10 percent of a library fund, while Carnegie, and later his foundation, would fund the other 90 percent. Middleport and Pomeroy both qualified, with the Middleport library completed in 1912 and the Pomeroy building (pictured) in 1914. In 1989, Pomeroy received a new, expanded library as the central site of a county system that includes branches in Reedsville, Racine, and Middleport, which is still housed in the Carnegie structure. (Courtesy of Meigs County Historical Society.)

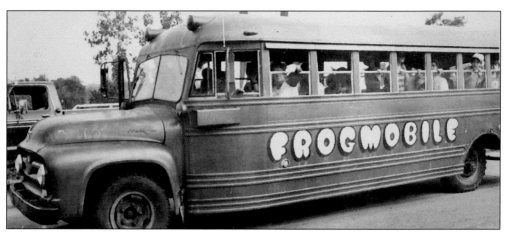

From the mid-1960s to the 1980s, Pomeroy was known for its annual summertime frog-jumping contest as part of the Big Bend Regatta. The festival included carnival rides, games, boats, and a parade. The infamous Frogmobile was owned by F.W. Crow II and participated for many years. (Courtesy of the *Daily Sentinel*.)

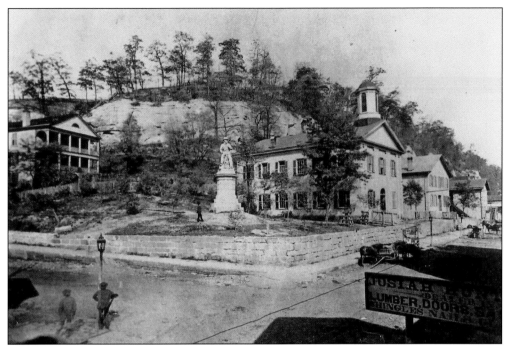

In 1841, the county seat was moved from Chester to Pomeroy, where it has remained. This image captures the courthouse before the 1880s expansion as well as the mansion behind the courthouse owned by Valentine B. Horton. (Courtesy of Meigs County Historical Society.)

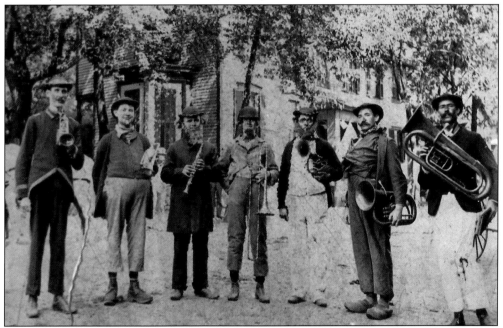

Given the strong German heritage of Pomeroy and Meigs County, a German band should come as no surprise. Pomeroy's seven-piece Little German Band included six brass instruments and one clarinet. It performed at various town functions and dances. (Courtesy of Meigs County Historical Society.)

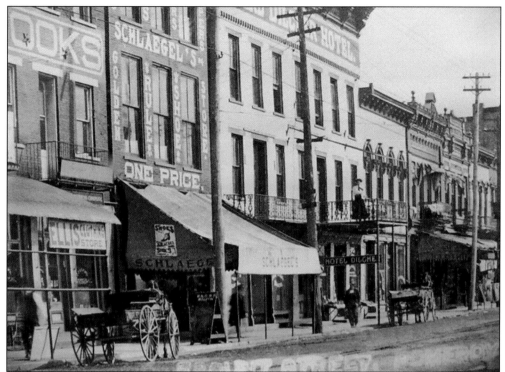

Nothing has been more iconic to Meigs County history than the businesses on Main Street in Pomeroy. This remarkable image shows several notable businesses in the late 1890s, including the Ellis Clothing House, Schlaegel's "Golden Rule" Shoe Store, the Grand Dilcher Hotel, and Gloeckner's Saloon. (Courtesy of Jordan Pickens.)

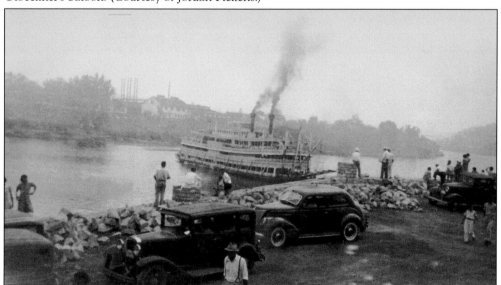

Built in 1937 as part of Pres. Franklin D. Roosevelt's Works Progress Administration, the construction of the Pomeroy parking lot put people back to work in Meigs County who had fallen on hard times during the Great Depression. This image shows the nearly completed parking lot with a steamboat pulling away. (Courtesy of Robert Graham.)

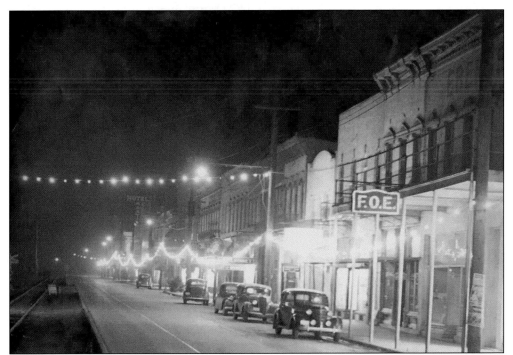

Pomeroy has always boasted a nightlife scene that comes to life once businesses close. For years, people have cruised Main Street, socialized in the parking lot, or taken in one of the taverns or the Fraternal Order of Eagles club. (Courtesy of Jordan Pickens.)

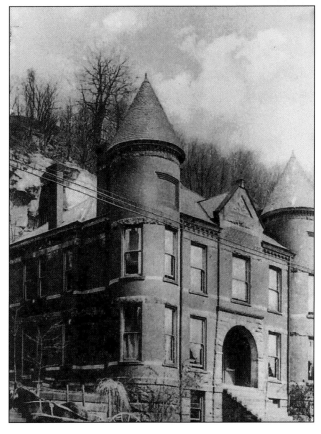

The Meigs County Jail and Sheriff's Office was built in the late 1860s on Second Street in Pomeroy, but Meigs County's first sheriff dates back to 1819. Benjamin Stout held the office until 1824, when he was replaced by Andrew Donnallay. (Courtesy of Meigs County Historical Society.)

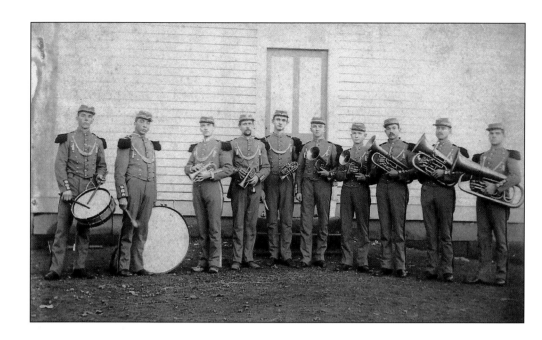

In the late 1890s and early 1900s, any place big enough to call itself a community boasted a brass band that played for patriotic holiday events, and Portland was no exception. The community has been a travel destination for history buffs, as it is the site of Ohio's only significant Civil War battle. Located along the Ohio River, Portland has never been an exception to flooding. (Both, courtesy of Robert Graham.)

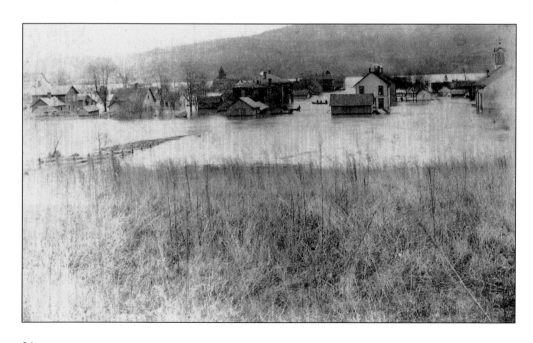

Originally known as Graham Station, Racine, laid out in 1837, was once nicknamed the "Paris of Meigs County." Pictured above is Racine in 1947, while Charlie McNickle's Sohio gas station is seen below in the 1950s. (Above, courtesy of Robert Graham; below, courtesy of John Bentley.)

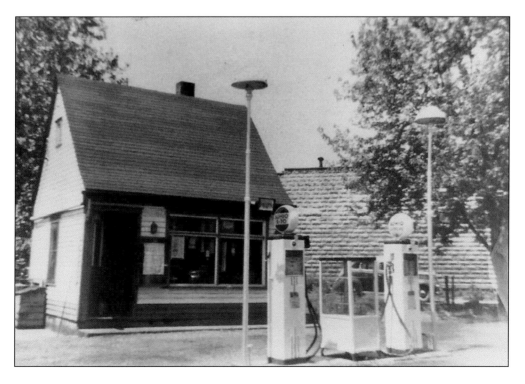

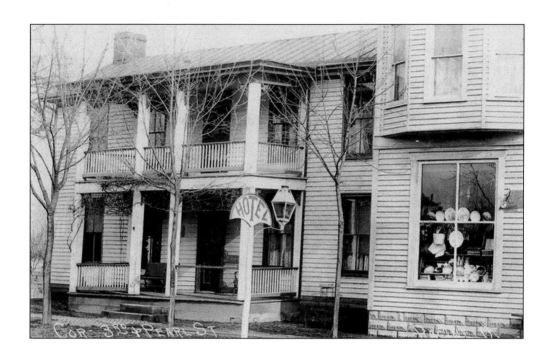

The Cooper House (above), located on the corner of Third and Pearl Streets, was one of two hotels in Racine. After surviving the flood of 1937, it burned shortly after. D.H. Wells built a store (below) in 1873; the Hayward family later used it for a hotel before it burned in 1922. The streetcar ran from Racine to Hobson. (Above, courtesy of Meigs County Historical Society; below, courtesy of Jordan Pickens.)

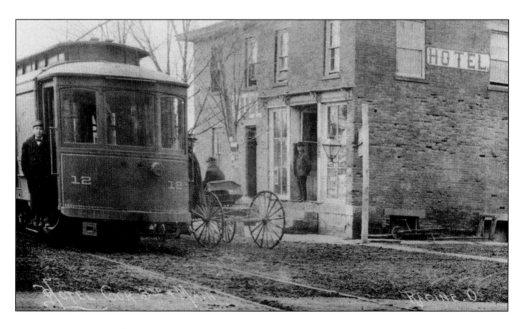

While the community of Rocksprings boasts only a handful of houses, it is home to the Meigs County Fairgrounds and a spring for which it earned its name. Originally a Native American watering spot, the spring at one time provided water for the animals at the Meigs County Fair. Livestock owners would pay children 25¢ per bucket of water to keep their animals hydrated. (Courtesy of Robert Graham.)

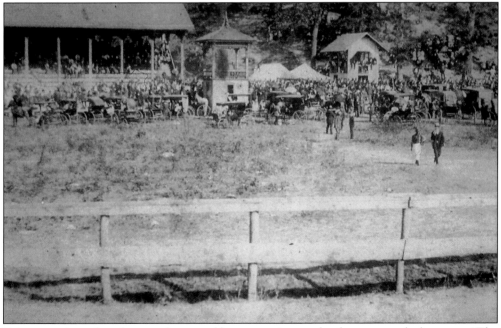

Fairgoers enjoy a day of quarter horse and harness racing at what has come to be known as "The Rock." The Meigs County Fairgrounds has entertained thousands of Meigs Countians for over 140 years. It is the only fairgrounds in Ohio with two levels, separated by a cliff, and its one-of-a kind curved grandstand built in 1890 is still used every year. (Courtesy of Robert Graham.)

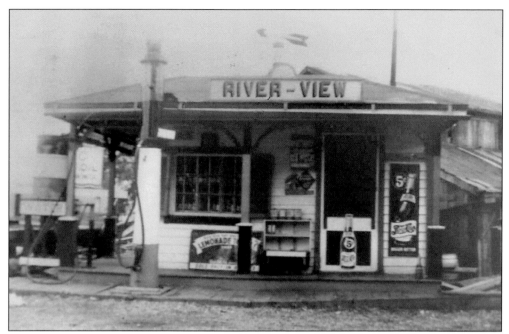

Originally Randolph's Landing, Reedsville is named after Major Reed and was laid out in 1855. Reedsville earned the nickname "Cooper Shop Town" because of its many cooper shops, which built casks and barrels that were sent upriver, usually to Pittsburgh. Pictured here is the iconic River-View gas station and general store. (Courtesy of Meigs County Historical Society.)

Although Wilkesville is just west of the county line in Vinton County, its annual Bean Dinner has been held in Salem Township at two different locations. Since 1946, the American Legion Grove in Section 33 has been the site of the event. White beans are boiled for three and half hours before being served with only crackers and black coffee to commemorate the main fare of Civil War soldiers. (Courtesy of Ivan Tribe.)

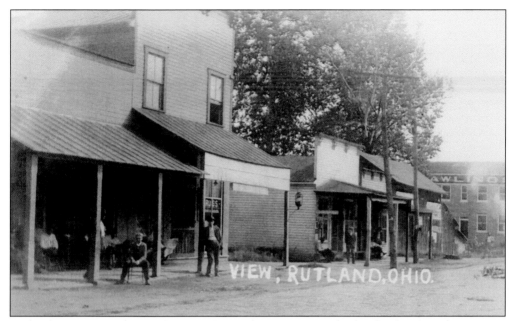

Rutland was organized around 1812 and earned its name from the family of Gen. Rufus Putnam, who came from Rutland, Massachusetts, in 1790. This photograph was taken at Rathburn's Department Store, with a view looking down Main Street toward Rawlings Funeral Home. (Courtesy of Robert Graham.)

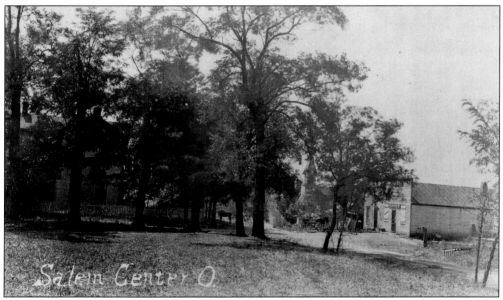

The Underground Railroad was said to have gone through Salem Center. Newspapers in Lewisburg, Virginia, offered a bounty of $2,000 for William Green, John Fordyce, and Thomas P. Fogg of Salem Center, accusing them of harboring slaves. Salem Center is shown here in the late 1860s. (Courtesy of Robert Graham.)

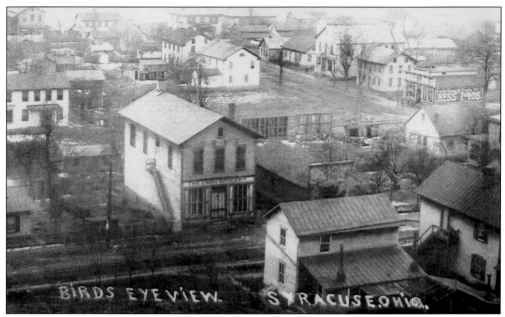

This image captures Syracuse in the 1920s. The Cash Grocery store (later Baer's Market) originally faced Third Street. In the flood of 1937, the building was lifted from its foundation and since then has been a business on Second Street. (Courtesy Mary Pickens.)

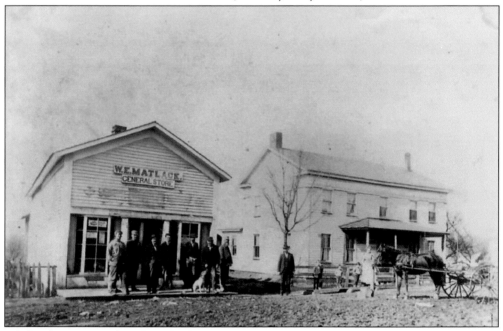

Of the three stores that flourished in Tuppers Plains in the old days—Matlack, Keller, and Barrett—that of William Matlack (1871–1943) seems to have been the most memorable, selling every necessity imaginable. For a time, the business even had an Overland auto agency and also kept a hotel nearby. The business did well from 1894 until 1936, when it burned. Matlack then opened a smaller store in his house, serving also as a hotel, that he operated until his death. (Courtesy of Meigs County Historical Society.)

Two

THE MEIGS COUNTY ECONOMY
BUSINESS, INDUSTRY, TOURISM, AND AGRICULTURE

The first settlers in Meigs County hoped to live by the Jeffersonian ideal as independent tillers of the soil, but the long miles of river frontage soon stirred Hamiltonian thoughts of commerce. The bounty provided by nature in the form of white salt and black coal, together with an evolving industrial revolution, also took hold. By 1850, the county sent 188,000 tons of coal and thousands of barrels of salt down the river. The annual production of coal in 1881 totaled 362,500 tons, while three salt producers reported a total of 1,004,146 bushels. Coal production fluctuated but boomed in the 1975–2000 era, when annual tonnage sometimes exceeded four million.

In 1881, sheep were the most numerous livestock, with 41,161 animals yielding 136,826 pounds of wool. Chickens laid 144,064 dozens of eggs, while farmers harvested 514,137 bushels of corn. Other crops included wheat and oats, with the latter a necessity in the days of horse dependence. Today, agriculture is still significant, especially in the river bottomlands where truck farming and greenhouses prevail. Overall, modern farming methods require fewer farmers than in earlier days.

Historically, manufacturing was limited, with much of it being very basic. The Germans produced fine ironwork seen on ornate porches for decades. Local breweries, such as Wildermuths, produced beer for residents. The county even had an organ factory at one time. However, the decline in manufacturing was so significant that by 1979 Beulah Jones reported that Imperial Electric and Royal Crown Bottling were Middleport's main employers.

After 1881, the rivers and rails still provided employment for the common man. Hobson Yard thrived from 1901 to 1953, but like the salt business before it, railroad work steadily declined, leaving only a few employees at Norfolk Southern Railway today. In addition to riverboats, the lock-and-dam system also helps support county families. With the growth of government, social-service agencies employ many people outside of the lock-and-dam system. Education supports both professional teachers and supporting staff. Many Meigs residents also work outside the county.

A growing investment in tourism entices visitors to spend time and money in Meigs County. Public and private resort campgrounds attract many visitors. Jorma Kaukonen (Jefferson Airplane guitarist) established the Fur Peace Ranch near Darwin in the late 1990s for guitar workshops and live concerts. Local festivals, music and arts performances, and traditional events provide entertainment and enrichment for tourists and residents. These help maintain community spirit and keep the county moving.

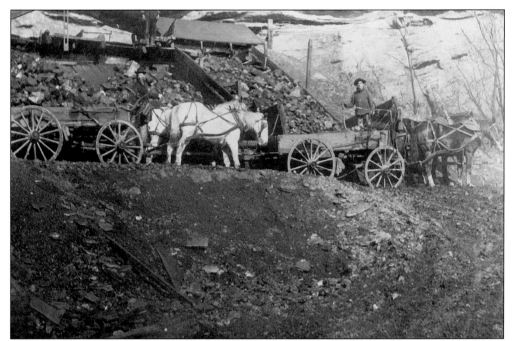

This photograph captures the manner and style of coal mining that prevailed in Meigs County prior to the more modern technology introduced to the county in the early 1970s. Blue Diamond Coal Company operated where the Mulberry Community Center now sits. (Courtesy of Robert Graham.)

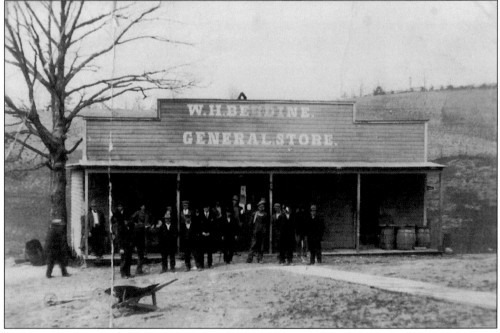

The Berdine Store at Bald Knob, north of Spiller and west of Portland, served a rural clientele in Lebanon Township for years. In many respects, it was typical of the country stores that once dotted the bucolic landscape. (Courtesy of the *Daily Sentinel*.)

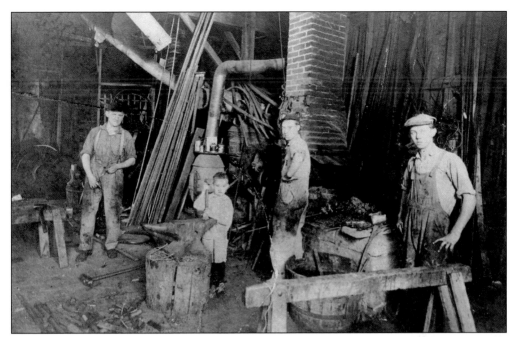

"From buggies to Buicks" was the decades-long motto of the Blaettner family business. Founder Michael Blaettner emigrated from Germany in 1852 and established a blacksmith shop in 1853, which soon grew into a buggy and wagon factory in 1854. In 1916, the Blaettners entered the automobile business, and within a few years the blacksmithing, buggy, and wagon parts of the business went by the wayside. (Courtesy of Meigs County Historical Society.)

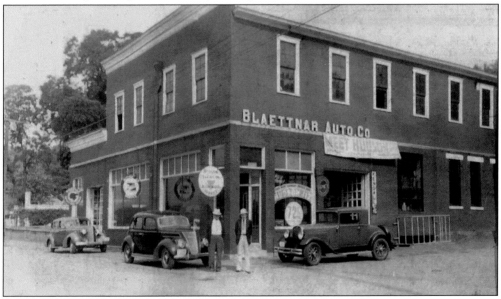

When John F. Blaettner added auto sales to the Blaettner blacksmith, buggy, and wagon business in 1916, he rode the wave of societal evolution, adding a Buick dealership in 1924 and later Pontiac cars and GMC trucks. This made the "buggies to Buicks" slogan a reality for decades under his guidance, as well as that of his son Fred Blaettner and grandson John W. Blaettner. The dealership was later sold to the firm of Smith-Nelson. (Courtesy of Meigs County Historical Society.)

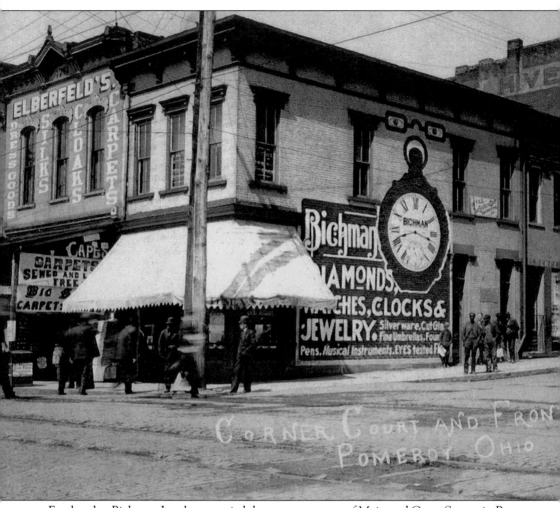

For decades, Bichman Jewelry occupied the western corner of Main and Court Streets in Pomeroy. On the left is the older pre-1911 Elberfeld Store, which later relocated to 106 East Main Street. August Goessler apprenticed under Bichman, later bought him out, and had another store at 113 Court Street. (Courtesy of Meigs County Historical Society.)

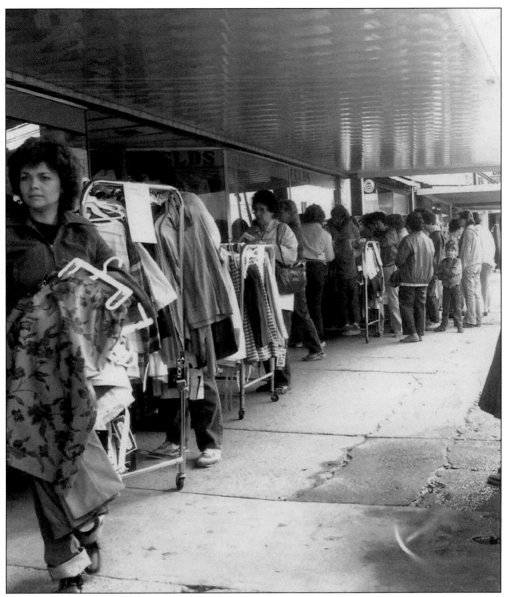

From 1864, the Elberfeld family operated retail establishments in downtown Pomeroy. The first Jacob Elberfeld (1834–1887) emigrated from Germany and started his first store, a grocery, in 1864. The family later moved to another location before settling in the former Grand Dilcher Hotel building in 1911, where it grew into one of the more elaborate department stores in southeast Ohio under the direction of Jacob Bauer Elberfeld (1868–1963). At one time, other Elberfelds had stores in Chillicothe, Jackson, Marietta, Parkersburg, and Logan. The Elberfelds ended their long history in Pomeroy in 1989, but descendant John Anderson operated a furniture and appliance store until late 2013. The building is now home to Weaving Stitches Gift Shop. (Courtesy of Meigs County Historical Society.)

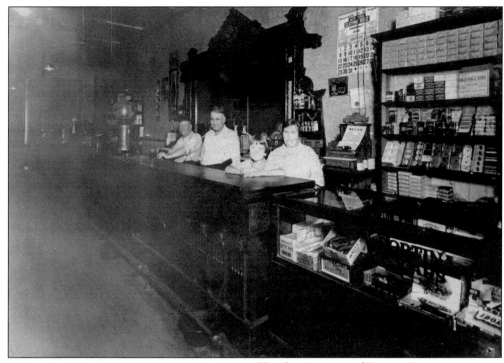

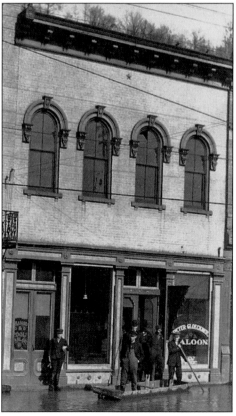

Gloeckner's is one of Pomeroy's most notable saloons. Like many other Pomeroy establishments, it was German-American in origin. Recently, it has become known as Sonny's Tavern, but owner Sonny Gloeckner retains the Gloeckner name on his sign in smaller print, and locals still call it Gloeckner's. (Both, courtesy of Meigs County Historical Society.)

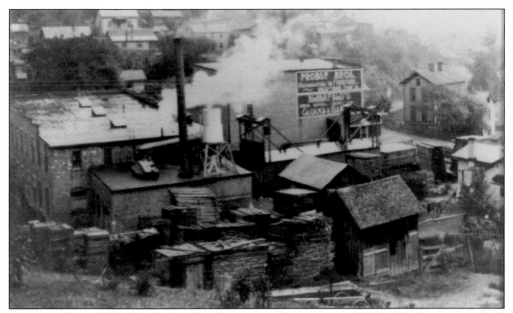

George Probst established Probst Brothers Furniture in Pomeroy around 1870. The factory specialized in cabinets and dressers, and Meigs Countians could purchase their "top-of-the-line" products exclusively at Elberfeld's in Pomeroy. (Courtesy of Meigs County Historical Society.)

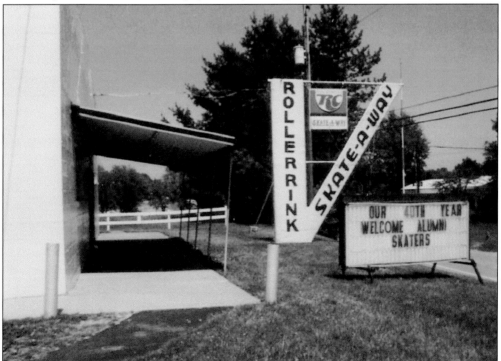

The Skate-A-Way roller rink opened in March 1956. It was built, owned, and operated by Marion and Dorothy Cowdery and their daughter and son in-law Marilynn and Bob Trussell. The Skate-A-Way provided fun and entertainment to young and old for 50 years, closing August 27, 2006. (Courtesy of Mary Stobart Cowdery.)

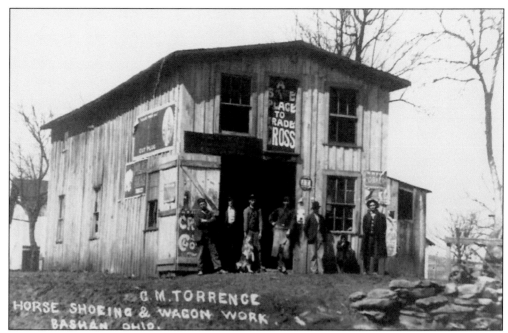

The Torrence Blacksmith shop in Bashan, which repaired and cast metal parts of wagons, provided farmers with important necessities in the pre-automobile era. Note the ad for Cross's Store in Racine, the largest in that part of the county. (Courtesy of Meigs County Historical Society.)

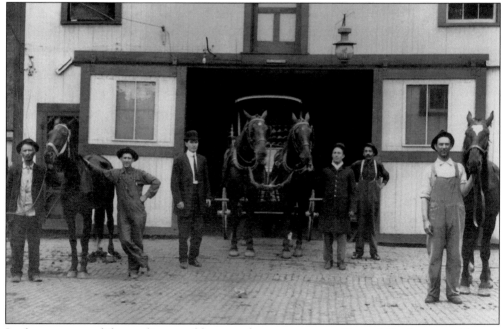

In the pre-automobile era, livery stables served many purposes. Townsfolk who owned horses could stable them there, while those who did not could rent horses, buggies, and wagons. Horse feed could be purchased at the livery as well. It was a good place for men to socialize when they had spare time. Reynolds Brothers provided all services at its Walnut Street stable. (Courtesy of Meigs County Historical Society.)

The Cross General Store has a history dating to 1840, when Lucius Cross (1798–1883) started a small store to accommodate employees, as he was involved in tanning, sawmill, gristmill, woolen mill, and flatboat building. Son Waid Cross began his career as a merchant in 1860 in a two-story brick building. His individual business expanded to the point where he constructed the three-story brick building pictured here in 1892. He took in his two sons as partners in the business. After Waid's death on February 18, 1912, the business became Waid Cross' Sons for more than 80 years. (Above, courtesy of Robert Graham; below, courtesy of Meigs County Historical Society.)

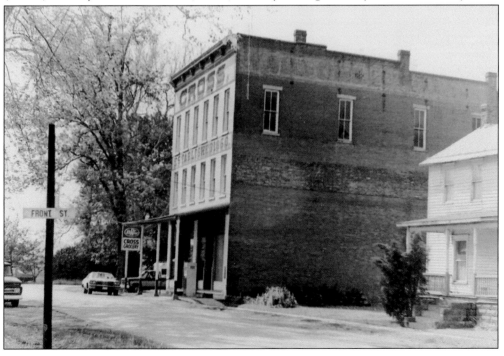

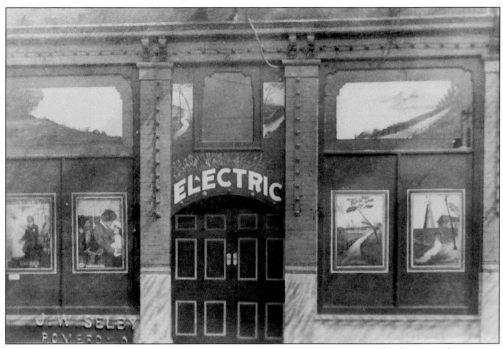

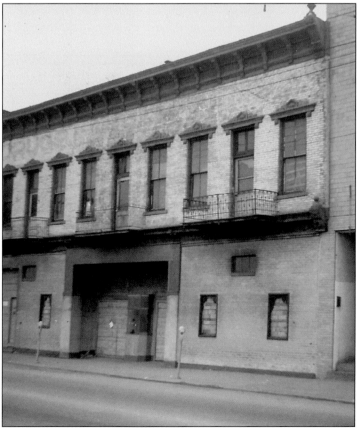

The history of motion picture theaters in Meigs County is intertwined in the business career of Helen Straile Zweifel Lyons (1894–1980). The early 1920s found Helen and Nyman Zweifel operating the Electric and Majestic in Pomeroy and theaters in Racine, Rutland, and Jackson with the aid of her sister and brother-in-law. Nyman died in 1927, and then Helen and her sister Henrietta expanded to the Liberty in Middleport. A rival owner started the Bendvue in the mid-1930s, but Helen (remarried to John Lyons in 1930) soon bought him out. (Both, courtesy of Meigs County Historical Society.)

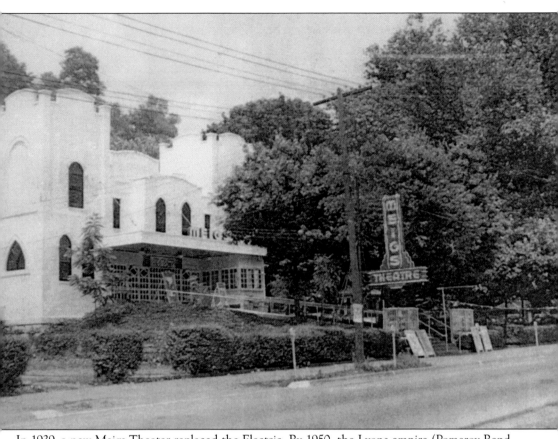

In 1939, a new Meigs Theater replaced the Electric. By 1950, the Lyons empire (Pomeroy Bend Theaters) consisted of the Meigs, Temple, and Bendvue. Competition from television during the 1950s led to the closing of the latter two (as well as the Liberty), but the Meigs continued until 1977, when Helen retired at age 83. (Courtesy of Frank and Ann Ryther.)

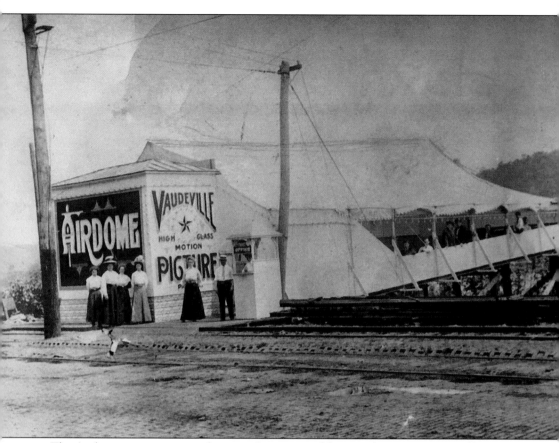

The Airdome was an open-air theater, a forerunner of drive-in theaters. It operated between 1904 and 1913, before the flood washed it away, in a portion of where the parking lot is now located. John Kasper ran the operation of silent films and live acts that were presented in a tent during the warm season. After the flood, Kasper moved to another location for a time, but it was never as successful. (Courtesy of Robert Graham.)

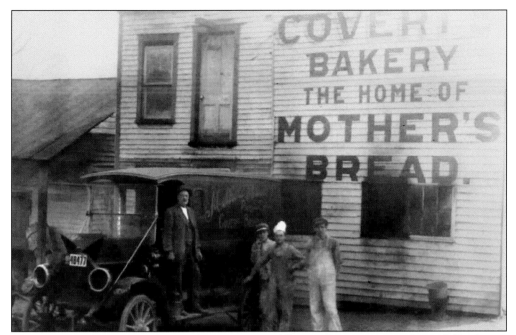

The Covert Bakery was a thriving business in Middleport for many years. One of the Covert children, William, had a long career as a Methodist minister in Ohio and Florida. Two of the Covert grandchildren live today in Florida and Louisiana. (Courtesy of Meigs County Historical Society.)

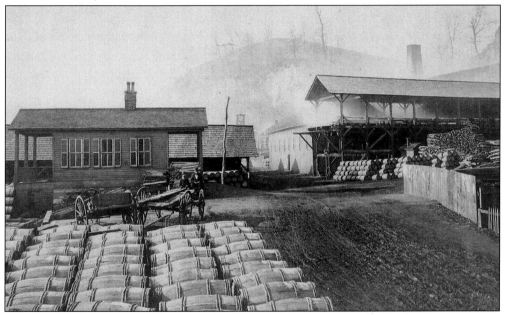

Dabney Salt Works was one of nine salt furnaces in Meigs County in the late 1860s. On average, 200 to 250 barrels of Meigs County salt were produced daily, with each barrel containing 250 pounds of salt. Only a quarter of the salt was barreled, with the remaining being shipped in bags. Meigs County Salt was extensively shipped to several ports on the Ohio, Mississippi, and Tennessee Rivers. (Courtesy of Robert Graham.)

Prior to the era of motion pictures, radio, and television, most towns had opera houses, where both local and traveling talent performed dramatic and musical entertainment programs. Stages and seating areas were often on the second floor of a store building or sometimes on a first floor with a balcony. In the 1950s, some years after the opera house closed, the building burned and the ruins were cleared away. (Both, courtesy of Meigs County Historical Society.)

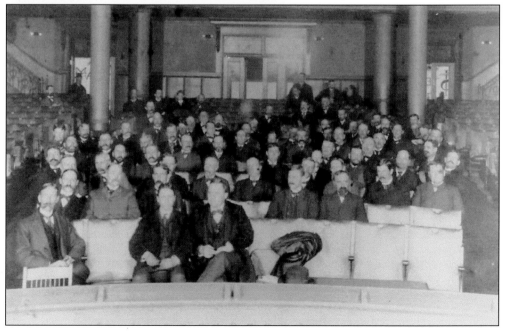

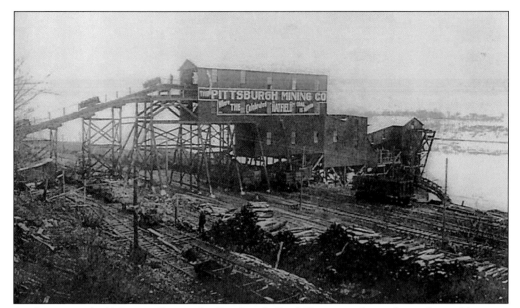

At the east end of Minersville was the Pittsburgh Coal Company. Its coal was shipped by river, and during the streetcar age it was hauled by rail, pulled by a steam dummy and electric motorcar. The company abandoned its work in the 1920s, and the building burned around 1950. There are at least 14 abandoned mines within Minersville that served commercial and household purposes; some were sealed during the days of Pres. Franklin Delano Roosevelt's WPA. (Courtesy of Meigs County Historical Society.)

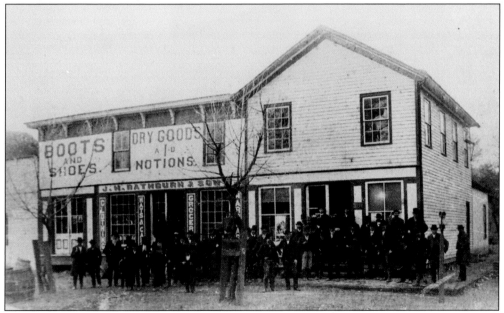

Rathburn's Department Store has occupied the corner of Main and Salem Streets in Rutland since 1858. The Rathburn family opened a store in Middleport, which later became the Middleport Department Store. Both stores carried everything from sewing equipment to farm machinery. In 1926, the Rutland store in this photograph caught fire and was replaced with the building that houses the Rutland Department Store, owned by Jim Birchfield. (Courtesy of the *Daily Sentinel*.)

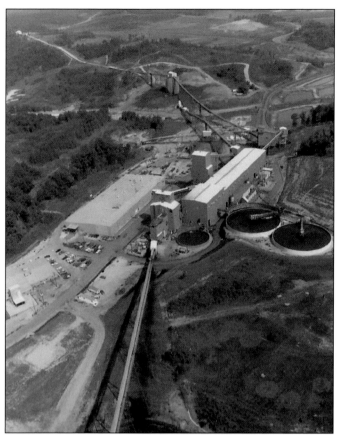

The Southern Ohio Coal Company organized in 1970 to supply coal for the Gavin power plant near Cheshire. Meigs No. 1, just east of Salem Center, and Meigs No. 2, at Point Rock, began producing in 1973, surpassed a million tons in 1975, and peaked at 4,671,674 tons in 1991. That year, the company employed 1,260 workers from Meigs and adjacent counties. Environmental restrictions and the exhaustion of the supply caused employment to decline to 700 by 1997, eventually closing in 2003. In 1990, the company paid $1,714, 989 in taxes to Meigs County, of which $803,490 went to the Meigs Local School District. Wages and benefits to workers from Meigs County surpassed $18 million that year. (Both, courtesy of Darla Garvin.)

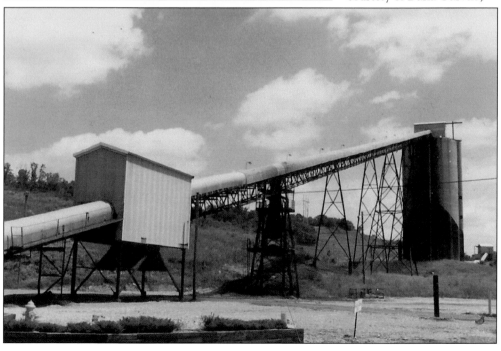

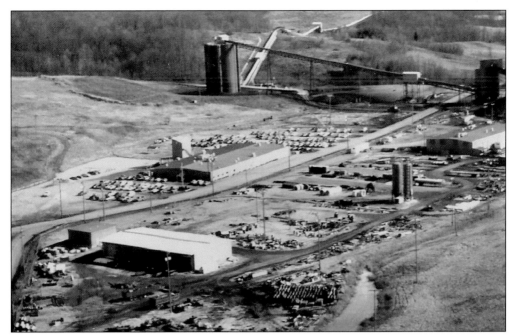

From 1973 to 2003, the Southern Ohio Coal Company Meigs No. 2, at Point Rock, Columbia Township, sent millions of tons of coal to supply the Gavin Plan in Cheshire. Slightly smaller than Meigs No. 1, this mine poured millions of dollars in wages, benefits, and taxes into the local economy. (Courtesy of Darla Garvin.)

Gottlieb Wildermuth established the Wildermuth Brewing Company, later known as the Roller Mill Brewing Company, on Condor Street in Pomeroy from around 1870 to 1919. The brewery bottled premium lager beer and manufactured artificial ice. This image captures workers with loaded wagons of beer ready to be enjoyed in Meigs County saloons. (Courtesy of Meigs County Historical Society.)

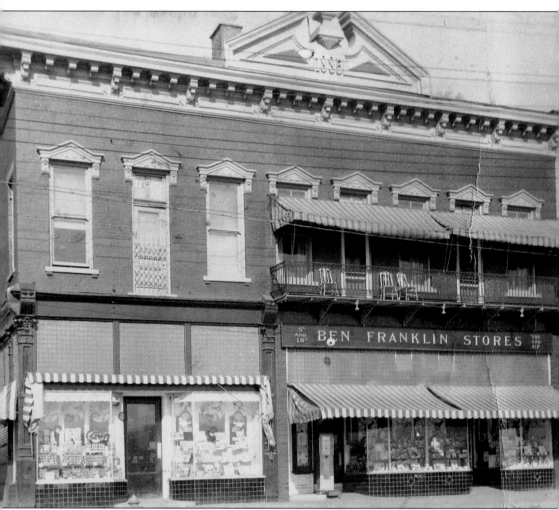

Ben Franklin Stores was a five-and-dime chain not unlike the better-known F.W. Woolworth Company. The Pomeroy store graced Main Street for many years in the building that originally was owned by J.A. Franz and constructed in 1885. (Courtesy of the *Daily Sentinel*.)

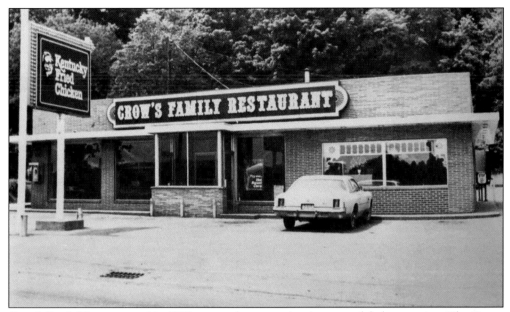

Crow's Steak House opened in 1957 as a modest operation in a remodeled gas station. The Crows added a Kentucky Fried Chicken franchise in 1960 and enlarged their facilities in 1961. As the decade passed, Crow's evolved into the "in place" to eat in Pomeroy and remained so for a quarter century. In 2004, however, it was dismantled and rebuilt as a combined KFC/Long John Silver's fast-food restaurant. (Courtesy of Jordan Pickens.)

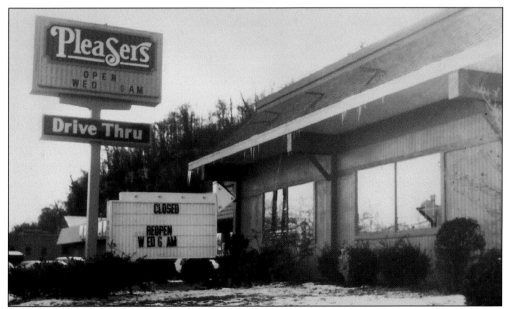

Located at 698 West Main Street in Pomeroy just south of the Pomeroy-Mason Bridge, Pleaser's was a pioneer in fast food in the area, but increasing competition took its toll, and the location has since become an AutoZone store. (Courtesy of the *Daily Sentinel*.)

The Meigs Inn in Pomeroy had a history dating back to 1879, as first the Remington Hotel and then the Martin Hotel. It was remodeled and reopened as the Meigs Inn in January 1972 with 31 guest rooms and a dining and banquet room with live entertainment on Friday and Saturday nights. The hotel was gutted by a disastrous fire in 1986, and the remaining shell met demolition not long after. (Courtesy of Robert Graham.)

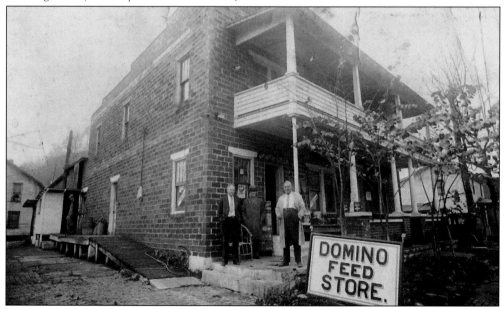

The Domino Feed Store in Middleport was built in 1927. Owned and operated by Oscar Myers, it specialized in animal feed. Pictured here, from left to right, are Dayton Ashworth, Will Bichman, and Oscar Myers. (Courtesy of Meigs County Historical Society.)

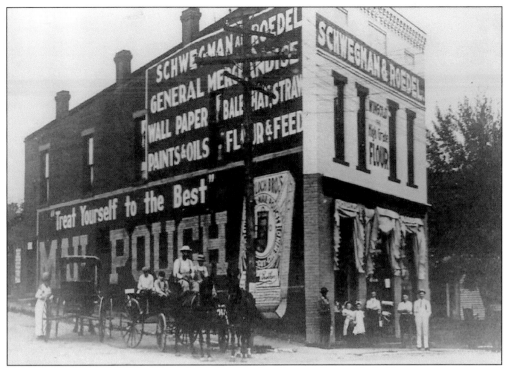

Schwegman & Rodel—a retailer of general merchandise, wallpaper, baled hay, straw, paints and oils, and flour and seed—was located at the corner of Kerr's Run and Main Street in Pomeroy. It was a leading merchant of Mail Pouch tobacco, with the motto "Treat Yourself to the Best." (Courtesy of Meigs County Historical Society.)

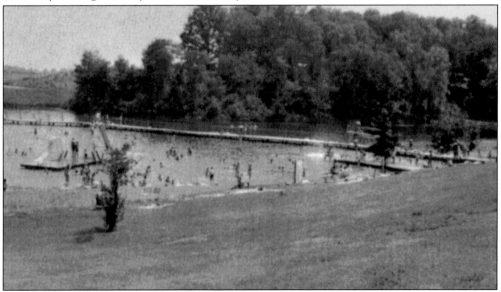

Royal Oak Park was opened in 1965 and developed by Horace Karr, a Chester native and owner of the Karr Construction Company. Over the years, the park expanded into a large resort area offering swimming, boating, fishing, and a wide variety of outdoor activities. In recent years, it has been sold and renamed Kountry Resort Campground. (Courtesy of Robert Graham.)

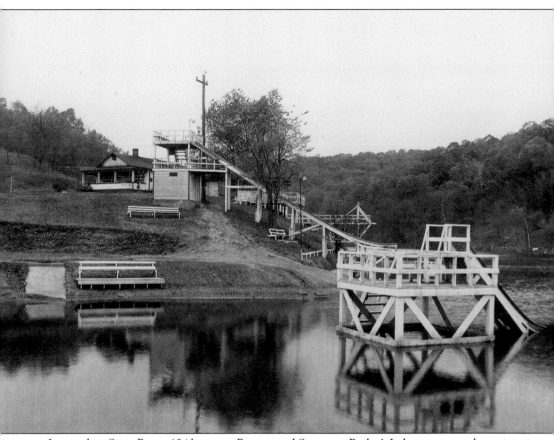

Located on State Route 124 between Racine and Syracuse, Bailey's Lake was a popular swimming hole in the 1960s and 1970s that offered various slides and diving boards. The property is now owned by the Cundiff family, who operate it as Maplewood Lake. (Courtesy of Robert Graham.)

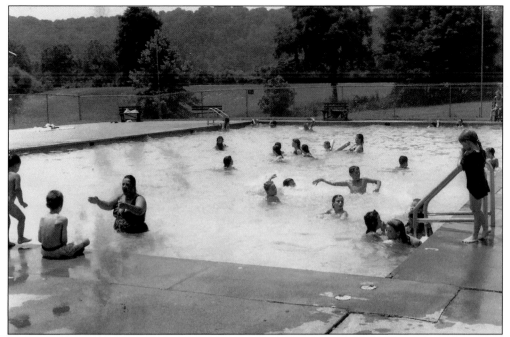

Built in 1977 and named after former mayor Herman London, who worked diligently to gain funding for a village pool, the London Pool in Syracuse offers a junior Olympic–size pool complete with two diving boards, two slides, and an additional pool for younger children. (Courtesy of the *Daily Sentinel*.)

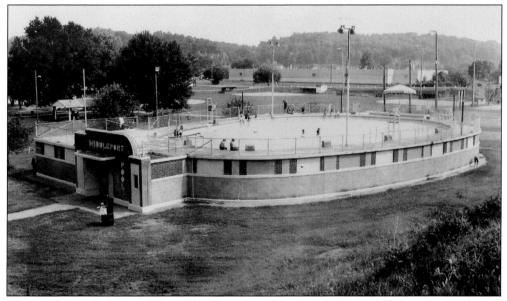

The Middleport Pool, one of few public aboveground pools in the state of Ohio, entertained many guests looking for a way to beat the heat each summer. Sadly, because of a lack of funding, the pool closed in the early part of the 21st century. (Courtesy of John Bentley.)

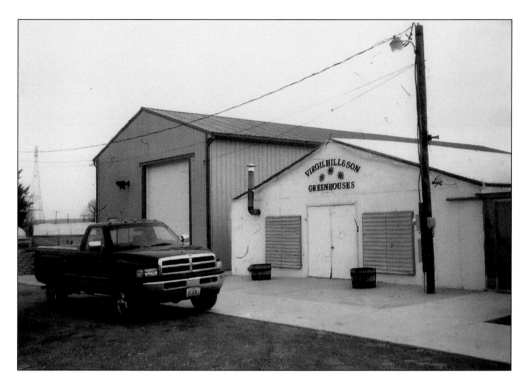

Truck farming and greenhouses have long been economically significant in the Ohio River valley bottomlands extending from Reedsville to Racine. Specializing in tomatoes, cabbage, and flowers, Virgil Hill and Sons Farm and Greenhouse is typical of several such operations upriver from Racine in the Letart and Great Bend areas. (Both, courtesy of Deanna Tribe.)

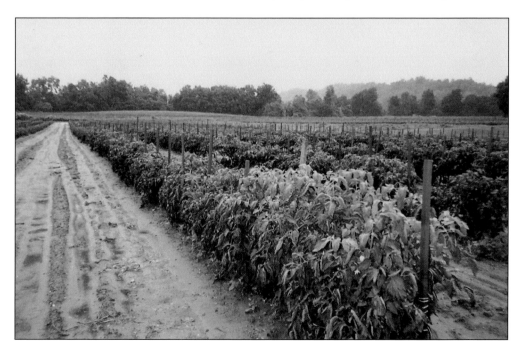

Three

PILLARS OF THE COMMUNITY
CHURCHES, LEADERS, LODGES, AND SCHOOLS

In small towns and rural areas during the 19th and 20th centuries, a number of institutions helped bind society together in viable communities. This was true of Meigs County, where a plethora of such organizations flourished. A 1919 study showed that Meigs had a church for every 197 persons. While many were small, they played a social role as well as a religious one. Methodism was the most popular denomination; however, many other churches had strong congregations as well. In the 20th century, a variety of Evangelical and nondenominational groups competed with older congregations.

Communities also have the means to advance some persons to leadership positions. In the mid-1800s, Meigs County turned out two persons who had careers in the US Congress: Valentine B. Horton, who promoted mineral and industrial development, and Tobias A. Plants, who led in finance. Other notable people exhibited leadership far from home, serving as reminders that those from the local area could achieve success anywhere, while those who remained served their hometowns with distinction.

The years 1850 to 1950 have been termed "the great age of fraternalism." Meigs Countians found numerous opportunities to participate in "a nation of joiners." Masons, Odd Fellows, Knights of Pythias, Modern Woodmen, and the Grange all had active bodies, built halls, and had ladies auxiliaries demonstrating the increasing significance of women in society. While some of these groups have waned, others remain influential. From the post–Civil War decades to more recent times, veterans groups have flourished in Meigs County, along with various social-service clubs.

Schools, of course, are important in educating youth, but they play an important social role as well. From the one-room district schools of the 19th century to a near century of continuing consolidation, schools have dominated the local scene. Since 1915, much of Meigs County progressed from several one-room elementary schools in each township to a progression of two-, three-, and four-room buildings until 2000, when all elementary grades centralized into three locations, one for each district. In 1945, Meigs County had 7 four-year high schools. By the mid-1970s, this number had declined to three: Meigs Local, Eastern, and Southern—with Columbia Township merging into the Alexander District in Athens County. While bigger schools offer more comprehensive programs, loss of community often results from the larger conglomerations. In addition, the University of Rio Grande–Meigs Center allows students to gain higher education in their home county.

Methodist meetings in the area that became Syracuse date from the 1830s, but the first church house was built in the mid-1850s. This structure burned in January 1920. The congregation planned a new brick structure, with the cornerstone being laid on August 20, 1922. The following May, the congregation moved into the basement, where it met for the next 26 years. The church was finally finished in March 1949. Since then, relative stability has reigned. (Courtesy of John Bentley.)

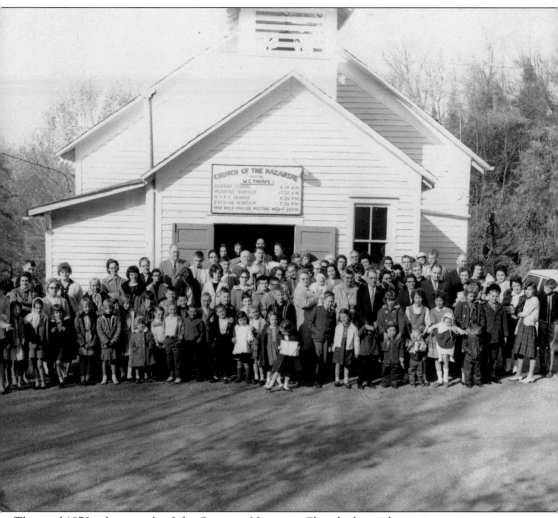

This mid-1970s photograph of the Syracuse Nazarene Church shows the entire congregation posing. This structure was replaced by a new one in 1990, but the old church is still in use as the Syracuse Mission Church. (Courtesy of Mary Pickens.)

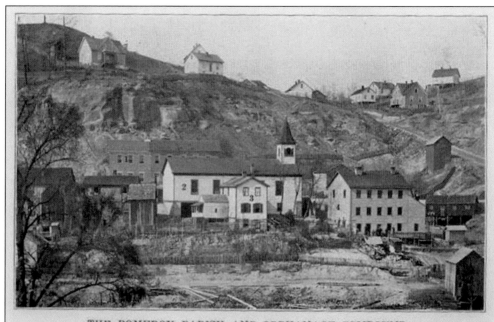

THE POMEROY PARISH AND ORPHANAGE COMPOUND:
1. SCHOOL. 2. CHURCH. 3. RECTORY. 4. ORPHANAGE.

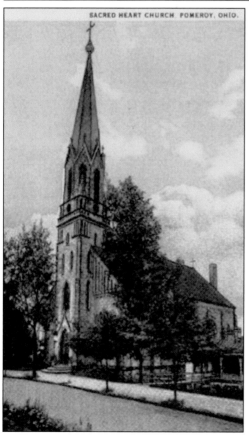

SACRED HEART CHURCH. POMEROY, OHIO.

Sacred Heart traces its origins to four German Catholic families who came to Pomeroy in 1839, but the first church dates from a decade later, when the parish was organized and a wooden church built to accommodate increasing numbers of German Catholics and some Irish immigrants. The present sandstone structure with its high steeple dates from 1898, and the tall spire was completed in 1899. In 1875, parishioners started St. Joseph's Orphanage in Pomeroy, but it was moved 27 months later to Columbus, where it became the cradle of what is now the Pontifical College of the Josephinum. At one time, Sacred Heart also had a parochial school. (Both, courtesy of Robert Graham.)

With a large German American community, it is hardly surprising that a Lutheran church would thrive in Pomeroy. In July 1849, local Lutherans organized and built a frame church at the corner of Second and Sycamore Streets. Services were conducted in German for many years. In 1884, the church burned and was replaced with a more spacious brick structure (pictured). In 1965–1966, a more modest third St. Paul's Lutheran Church replaced this one, and still thrives. (Courtesy of John Bentley.)

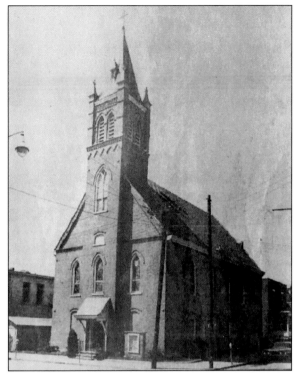

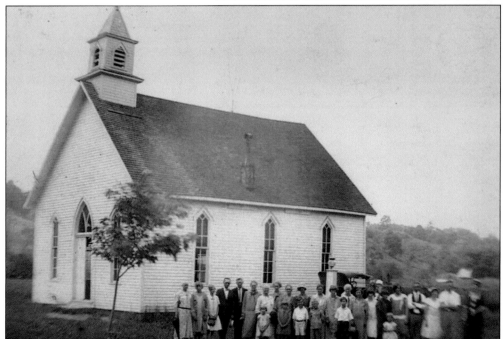

Today, nothing remains of the once vibrant hamlet of Hanesville near the junction of Routes 325 and 124 in Salem Township except for a homemade historical sign. But, such was not always true, as illustrated by this undated photograph of the Rose Hill Church and congregation. (Courtesy of John Bentley.)

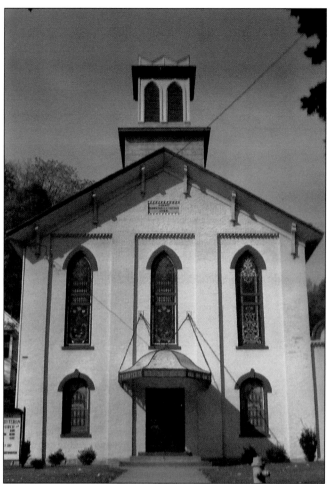

Presbyterians in Middleport built their imposing brick structure in 1860 at a cost of $6,000. Although not visible in a black-and-white photograph, its bright yellow color makes it one of the town's most easily recognizable buildings. (Courtesy of John Bentley.)

The Tuppers Plains Church of Christ organization obtained title to a half acre of land in 1852. Apparently, the congregation had an earlier church, but this current one dates from 1887. Later, the church added a tower and bell, which suddenly stopped ringing and was subsequently donated to a youth camp. Around 1959, additions were made consisting of Sunday school classrooms, a kitchen, and a fellowship hall. (Courtesy of John Bentley.)

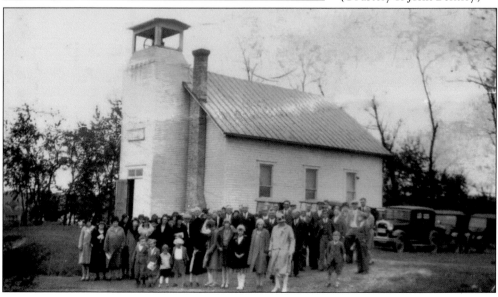

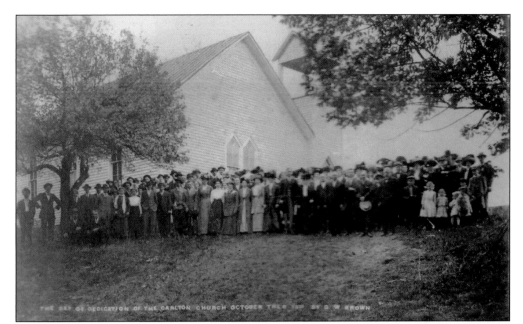

Carleton Church organized in 1872 in the Kingsbury area in southwest Bedford Township as St. James Episcopal Church. The original building burned in 1906, and the present one dates from 1909. It often changed denominations, first going to Free Methodist, then Cumberland Presbyterian in 1894, and then to Baptist, and for the last several decades it has been interdenominational. (Courtesy of Meigs County Historical Society.)

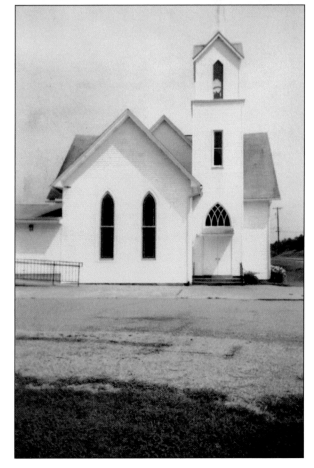

The Harrisonville Presbyterians organized in 1850 and built their first church that year. In 1894, the congregation constructed the present building. The church celebrated its 100th anniversary in 1994. (Courtesy of Deanna Tribe.)

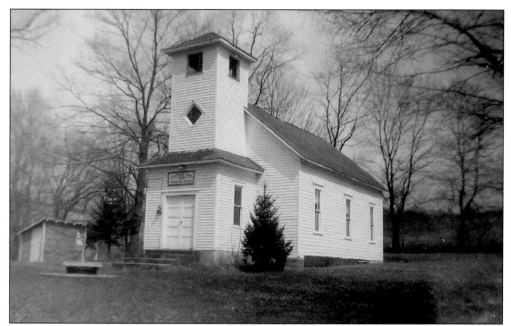

The Columbia Chapel Church of Christ dates from 1869. Since this photograph was taken in 1959, a fellowship hall has been constructed. The Castor Cemetery as well as the entrance for Meigs Mine No. 2 are nearby. In 1912, Point Rock got a second church, Nazarene. (Courtesy of Ivan Tribe.)

Pearl Chapel, located just south of the Athens County line in Scipio Township, was built in 1894 to replace the older Asbury Chapel on the county border adjacent to the Woodyard Cemetery. Usually served by pastors on the Albany Circuit, the church closed in 2000, and the building has since been torn down. (Courtesy of Ivan Tribe.)

The original Zion Church of Christ on Route 143 in northeast Rutland Township dates from 1872, when it was named by Lon Pickens. Later, a one-room school was built adjacent to it. When the church burned about 20 years later, Sunday services were held in the school. The church was rebuilt in 1893. The school later closed, and so did the church for a time. In 1948, rejuvenation took place in which the church was reopened, repaired, and improved. (Courtesy of Meigs County Historical Society.)

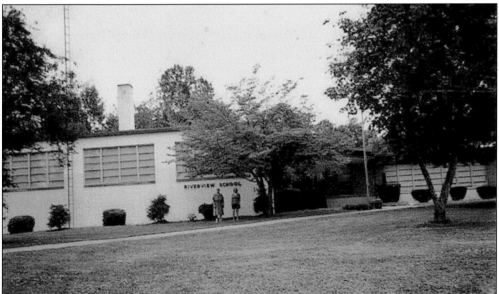

Part of the Eastern Local School District and built as a modern replacement for the outdated frame buildings in Long Bottom and Reedsville, Riverview was considered one of the most attractive, well-maintained schools along the Ohio River for a half century. After more centralization took place in 1998, former superintendent John Riebel and others hoped a suitable purpose could be found for the building, but it was not to be and Riverview was demolished. (Courtesy of Calee Pickens.)

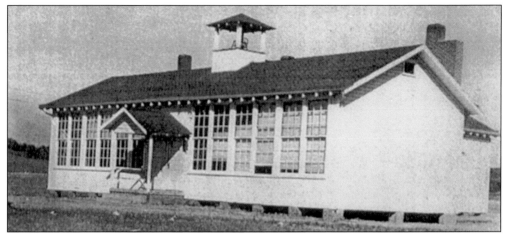

As the one-room schools in Lebanon Township began to consolidate after 1915, eventually only two remained—Portland and Spiller. In 1949, the Spiller School (pictured) was a three-room frame building, but its life span ended in 1951 when the two schools were combined into a new brick building at Portland. "The latter," said local historian Shirley Johnson, "provided Lebanon Township students with lunchroom facilities, a gymnasium, and a large equipped playground." (Courtesy of Calee Pickens.)

As Meigs County moved toward consolidating the older one-room district schools after 1914, Salem Township had two, respectively located in Salem Center and Dexter. The latter was a two-room building located north of the main rail crossing in the center of the community. The school served the area until the early 1950s, when the new brick school at Salem Center began serving the entire township. (Courtesy of Calee Pickens.)

Kingsbury School was a two-room structure that served the southern and western part of Bedford Township. A passage in Edgar Ervin's 1949 history suggests that by that time only a single room was in use. By the fall of 1949, all of Bedford's children were enrolled in the new Bedford Elementary, which in turn closed in 1967. (Courtesy of Jordan Pickens.)

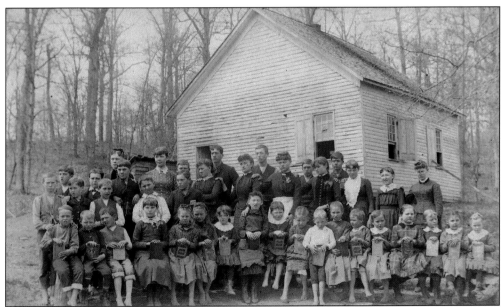

The Welsh School was one of the 10 one-room schools located in Scipio Township. The schoolchildren at Welsh came predominately from poor families. Students, many not wearing shoes, are pictured with teacher Ms. Hopkins in the early spring of 1887. (Courtesy of Meigs County Historical Society.)

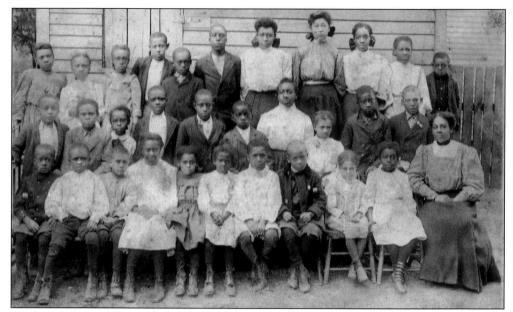

Kerr's Run Colored School held the highest percentage of attendance without an absence (97.2 percent) in one-room schoolhouses in Meigs County in 1872. The building, very small in size, housed these 31 students ranging from grades one through eight. (Courtesy of Meigs County Historical Society.)

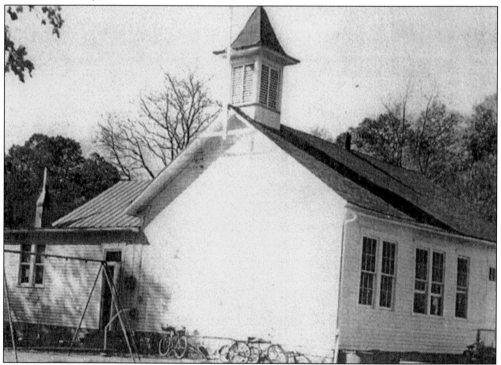

Today, the Laurel Cliff community of Salisbury Township is bisected by an improved State Route 7, but a generation ago it was recognizable as the home of this two-room school, which merged into the new Salisbury Elementary about 1952. (Courtesy of Jordan Pickens.)

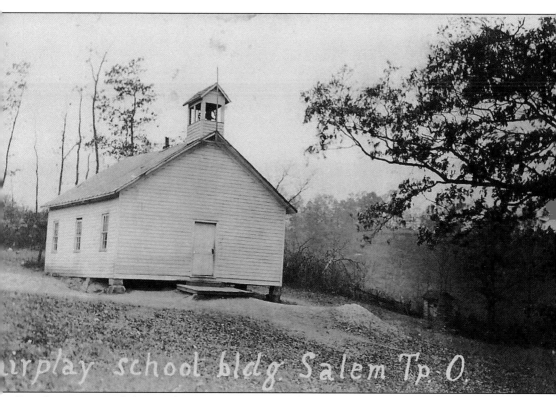

Fairplay was one of the southernmost one-room schools in western Meigs County. It was located in what was formerly part of Gallia County, before Meigs County was formed. Long abandoned because of consolidation, the building still stands in 2013. (Courtesy of Meigs County Historical Society.)

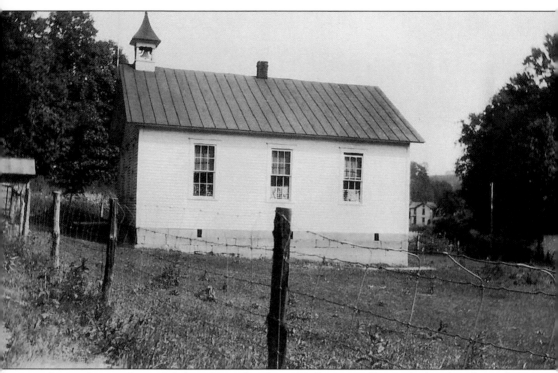

Located in northeast Salisbury Township, Long Hollow's enrollment declined in the mid-1940s, and the school closed. Students went to larger schools in the township and eventually to Salisbury Elementary. (Courtesy of Meigs County Historical Society.)

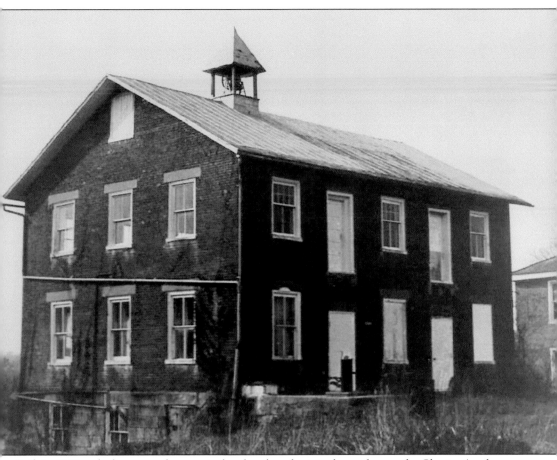

Built in 1839 and adjacent to the soon-to-be-abandoned original courthouse, the Chester Academy at various times was used as a teacher institute and as a public school during its long history. The lower story was also home to Shade River Lodge No. 453, Free and Accepted Masons, for 58 years; and the top story, for another 29. From 1934, Chester Council No. 323, Daughters of America, also met there. Like the old courthouse, the academy structure has undergone renovation and restoration to preserve it as a historic landmark. (Courtesy of Meigs County Historical Society.)

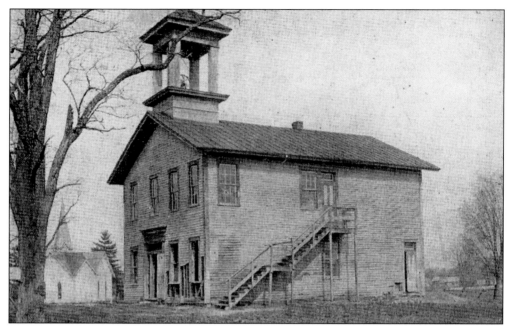

Another academy in Meigs County, the Tuppers Plains Seminary, was built in 1858–1859. For a number of years in the 1880s, Prof. Morris Bowers and his wife had charge of the institution. Their efforts boosted the seminary's reputation and enrollment, and, in 1883, area historian James M. Evans wrote, "Teaching seems to be a work of love with them." Bowers later sold the structure to the public system, and in 1913 it was demolished. (Courtesy of Meigs County Historical Society.)

After the Tuppers Plains Seminary building was demolished in 1913, classes were held for a brief time on the second floor of the Keller Store until construction of this building. Some years later, it was moved across the street, and in 1930 a new brick high school, known alternately as Tuppers Plains or Olive Orange High School, was built on the seminary site. When the new Eastern High School was built in 1956, this Tuppers Plains school building was abandoned and elementary grades took over the former high school. (Courtesy of Jordan Pickens.)

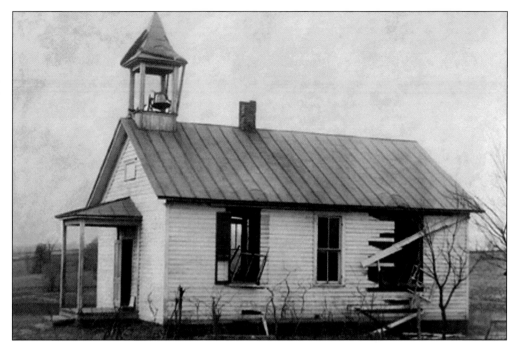

Carmel School in Sutton Township was struck by lightning in March 1912; the building suffered damage, and several students were injured. Repaired and reopened in the fall, Carmel later merged with McKenzie Ridge to form a two-room school called Pleasant View. (Courtesy of Jordan Pickens.)

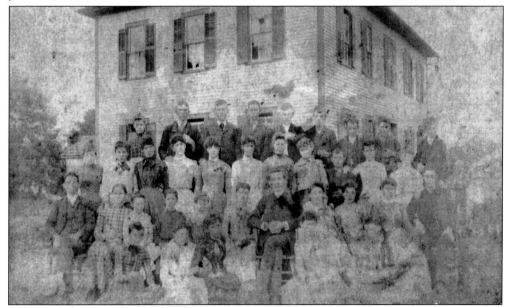

Built in 1879, Long Bottom School housed eight grades in a four-room, two-story frame structure. It served the Olive Township community for nearly eight decades before it merged with a similar building in Reedsville in 1957 to form Riverview, which in turn consolidated into a single Eastern Elementary adjacent to Eastern High School. In March 2013, the Long Bottom structure still stood in a dilapidated condition. (Courtesy of Jordan Pickens.)

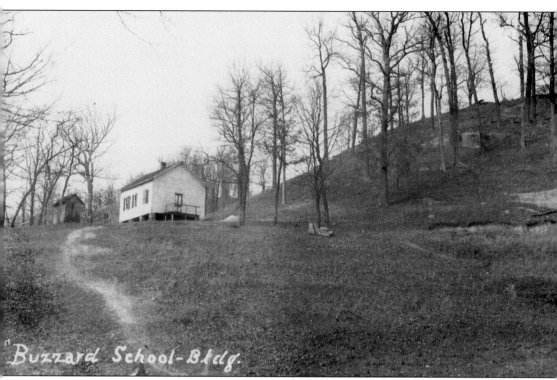

Buzzard School-Bldg.

Located in the extreme northwest corner of Meigs County near Raccoon Creek and Star Mill (Zeal Post Office) on Rutherford Road, Buzzard Run remained open until 1930, outlasting the other one-room schools in the township by a year. (Courtesy of Robert Graham.)

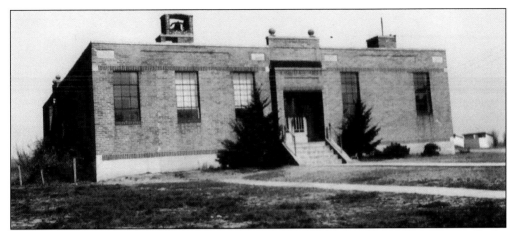

Located over a mile from Carpenter on the same tract as Columbia High School (pictured), the elementary school was built and opened in 1929 to consolidate one-room schools of the township and served local youth until 1951, when the high school closed and Columbia secondary youth moved to Albany. The frame building continued to be used for educational activities and as lunchroom for a few more years until an addition was built onto the brick room. It closed in 1966. (Courtesy of Harley Pickett III.)

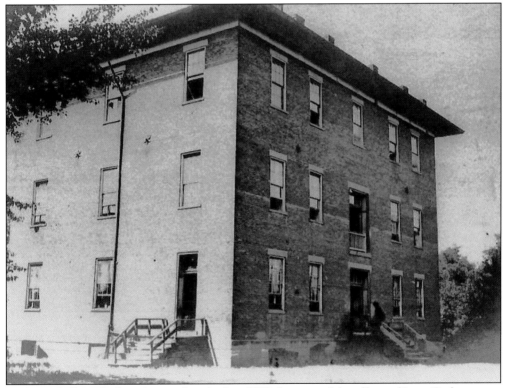

Carleton College, built and opened in the late 1860s because of the efforts of Isaac Carleton, was more likely an academy or private secondary school. Located between Minersville and Syracuse, the community of Carletonville was soon absorbed by Syracuse. After Carleton ceased functioning in its original form, it became an intermediate or three-year high school until it closed in 1930. (Courtesy of Meigs County Historical Society.)

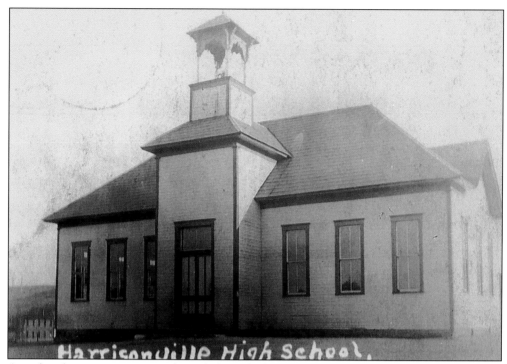

A modest three-room operation through the early decades of the 20th century, this frame building had four grades per room, including the high school. Beginning in 1930, a new brick Scipio High School brought all of the students to a central location that included the two-room school at Downington, known also as Pageville or Pagetown. (Courtesy of Calee Pickens.)

Located in Harrisonville, Scipio High School replaced an older building. After the high school closed in 1960, the Meigs County School Board merged the district with that of Rutland, and the building then became an elementary school until recent years, when all of the Meigs district schools were in a single location on Route 124 between Middleport and Rutland. Some youths along the northern border chose to transfer to Albany. (Courtesy of Calee Pickens.)

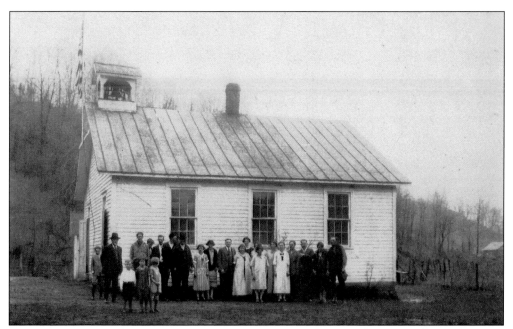

The Ball Run Schoolhouse, built around 1873, was located two miles from State Route 143 on Ball Run Road. Laurence and Eva Reuter deeded 84 square rods of land to the Salisbury School Board on May 26, 1873, for $100; all later school records have been lost. This photograph was taken around 1920. (Courtesy of Robert Graham.)

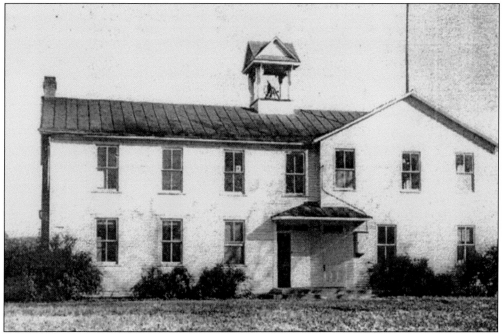

Of similar vintage to Long Bottom, Reedsville also had a two-story frame building. By 1944, when now retired county superintendent John Riebel started first grade, the state no longer permitted upstairs classrooms in wood structures, so all eight grades were housed in the two downstairs rooms, which he attended for eight years. (Courtesy of Jordan Pickens.)

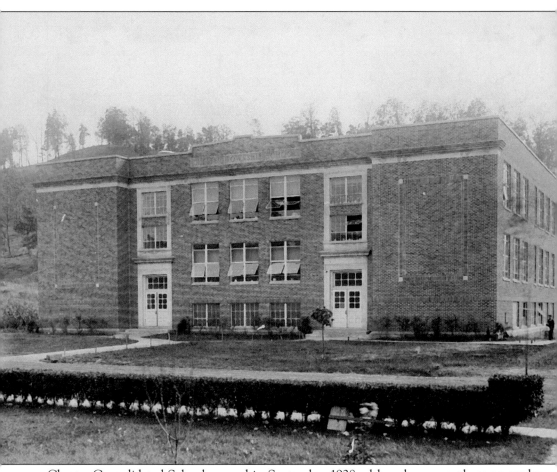

Chester Consolidated School opened in September 1928, although apparently some grades continued to meet in the old Chester Academy Building overlooking the town commons on the hill adjacent to the old courthouse. After the last Chester High School graduation in 1957, secondary-aged youth attended Eastern High School, midway between Chester and Tuppers Plains, but the structure remained in use for elementary grades until 1998. The former school still serves a variety of community purposes. (Courtesy of Robert Graham.)

The original Racine Public School (above) was located beside the Racine Methodist Church on Fourth Street. A new Racine Public School building was erected in 1911, which housed grades 1 through 12. Racine-Sutton High School (below) was constructed from 1929 to 1931, and kids in grades 9 through 12 went there. Students attended classes from 1931 to the early 1960s at this location before its replacement was built during the consolidation of Southern Local Schools. Racine-Sutton High School then continued to serve the people of Southern Local Schools as a junior high school until 2001. (Above, courtesy of Jordan Pickens; below, courtesy of Robert Graham.)

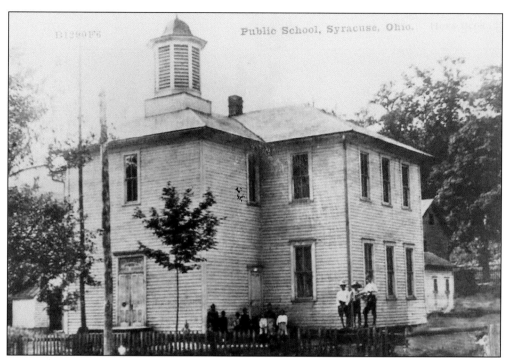

Before the erection of a newer building, classes in Syracuse was held in the old village hall on Second Street. The new building was constructed around 1930 and housed grades one through eight until 1962, when grades seven and eight were moved to Southern Junior High School. Later, the same was done to Syracuse Elementary, and the children of Syracuse and Minersville attended school there until 2001. (Both, courtesy of Mary Pickens.)

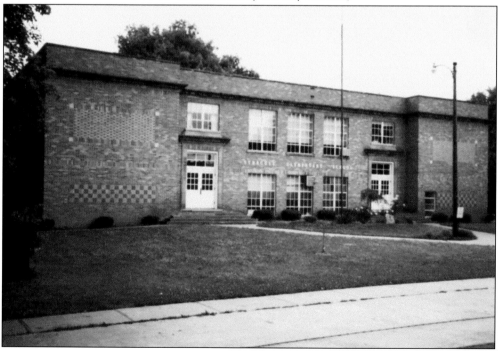

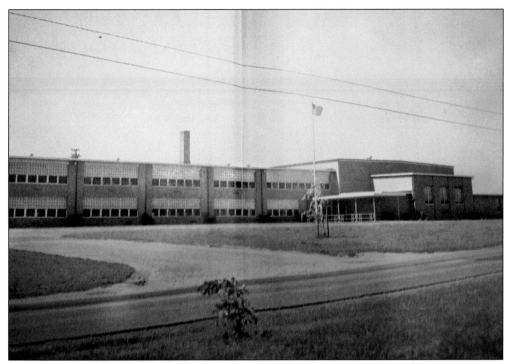

Built in the early 1960s, Southern High School was constructed with state-of-the-art equipment. Charles W. Hayman was the first principal of the consolidated high school, and the gymnasium was later named after him. With changing times, Southern High School was demolished to make way for a more modern building. (Courtesy of Jordan Pickens.)

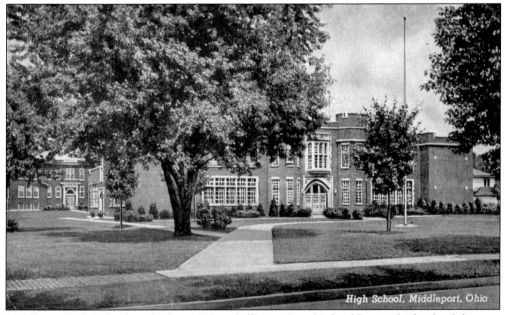

Middleport High School was built in 1915, and all Meigs Local School District high schools became one after 1968. This building continued to function as the junior high for Meigs Local until the new location just above Meigs High School opened in April 2003. (Courtesy of John Bentley.)

A modern high school, which would be the future home of the Pomeroy Panthers, was constructed on Main Street in Pomeroy in 1914. In 1968, Pomeroy, Middleport, and Rutland merged to form the Meigs Local School District. The new Meigs High School was built near Rock Springs; all high school students attend there. (Both, courtesy of Robert Graham.)

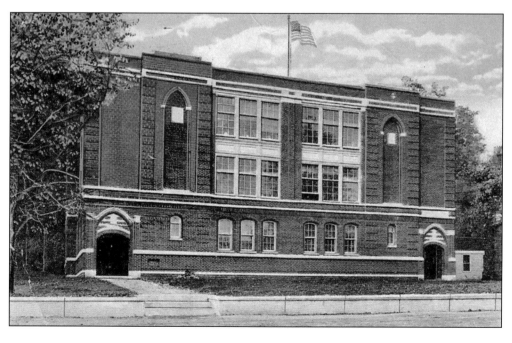

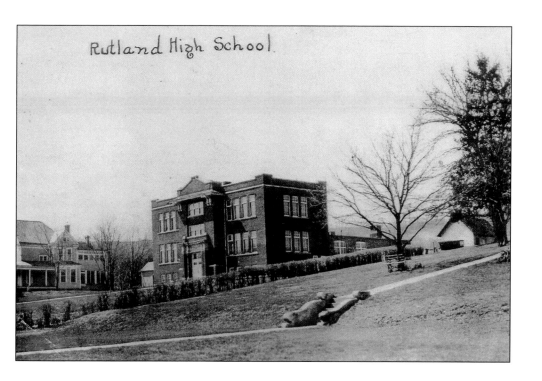

Built in 1914–1915, the Rutland Joint High School served students of the Rutland area and Salem Township, and after 1960, Scipio Township students attended the school. Under legendary coach Jim Vennari, Rutland became known for its quality football squads among smaller secondary schools. The last class graduated in 1968, and then Rutland was combined into the Meigs Local School District. The building was razed in 1994; however, the gymnasium remains and serves as the Rutland Civic Center. (Both, courtesy of Meigs County Historical Society.)

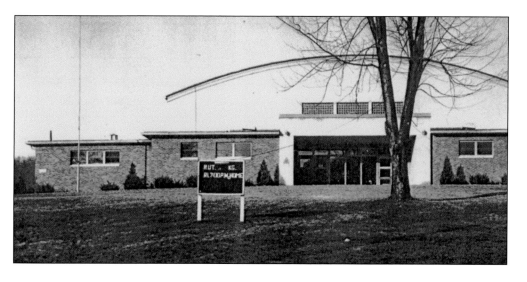

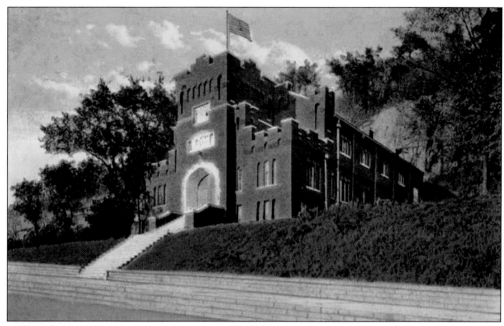

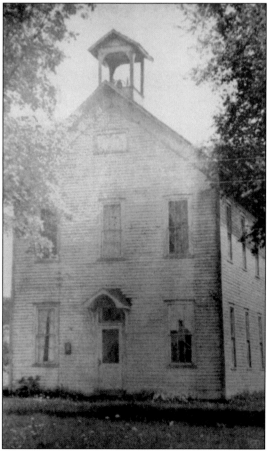

The Pomeroy Masonic Temple was originally built as a National Guard armory. Pomeroy Lodge No. 164 came into possession of the building in 1938. The York Rite Bodies and other Masonic lodges made use of the building. In the late 1980s, the building was condemned and subsequently demolished. The York Rite Bodies and some other groups moved to the Middleport Temple. The Pomeroy lodge eventually merged with the Racine lodge to form Pomeroy-Racine Lodge No. 164, meeting in Racine. (Courtesy of John Bentley.)

Harrisonville Masonic Lodge chartered in 1869 and held its early meetings at the DeCamp Institute in Pageville until the new temple on New Lima Road was completed in 1876. This frame building served the membership for a century until 1976, when the present one-story brick temple was built. The Harrisonville Eastern Star chapter, chartered in 1906, also met in both temples. The Harrisonville lodge attracted much attention in 1967 when it donated its original bell to the newly rebuilt St. John Catholic Church in rural Athens County. (Courtesy of Jordan Pickens.)

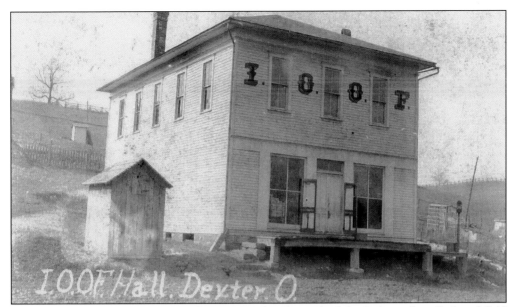

For decades, the hall of Amber Lodge No. 817 (1895–1942) of the Independent Order of Odd Fellows stood as the most imposing structure in Dexter. In 1896, the IOOF numbered 810,000 members nationwide. Meigs County boasted three lodges in Pomeroy (English, German, and Welsh) and one each in Middleport, Letart Falls, Racine, Syracuse, and Rutland, along with an African American lodge in Middleport. All of these organizations are now closed and nearly forgotten, with Mineral No. 242 folding in 2000. (Courtesy of Robert Graham.)

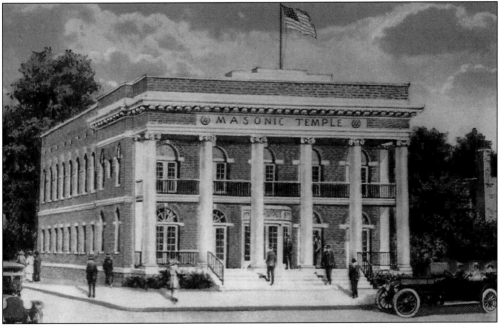

Erected in 1923, the Masonic Temple is home to Middleport Lodge No. 363 and in recent decades the Meigs County York Rite Masonic Bodies (previously housed in Pomeroy). It has also housed Order of the Eastern Star Evangeline Chapter No. 172 and the local Bethel of Job's Daughters. For several decades, the Temple Theater occupied the first floor. (Courtesy Jordan Pickens.)

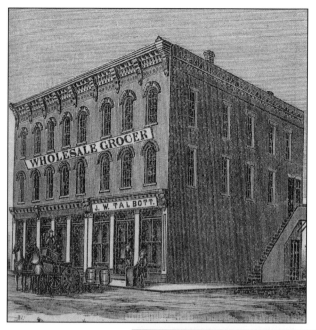

Founded in 1864 by Justus Rathbone, the Knights of Pythias ranked third among fraternal groups in membership after the Masons and the IOOF, numbering 800,000 in 1920. Meigs County had lodges in Chester, Dyesville, Long Bottom, Racine, Rutland, and Tuppers Plains. Middleport was likely the largest, as it boasted a Uniform Rank (military-style uniforms for parades and rituals) higher body. All of the Knights of Pythias lodges in the county are long defunct, but some lodges in the region continue to thrive. The Middleport lodge was housed above what is now the Foreman & Abbott Heating and Cooling building. (Courtesy of John Bentley.)

In 1874, the Grange movement swept through Meigs County with 20 bodies being chartered in a single year alone, but of those only the Star Grange survived into the 21st century. This hall served members' needs from 1876 until 1997, when it was replaced by a new structure (Star had merged with Laurel No. 1030 after its hall burned in 1987). Other Granges remain active in Meigs County to the present, but all date from 1910 or later. (Courtesy of Tom Gannaway.)

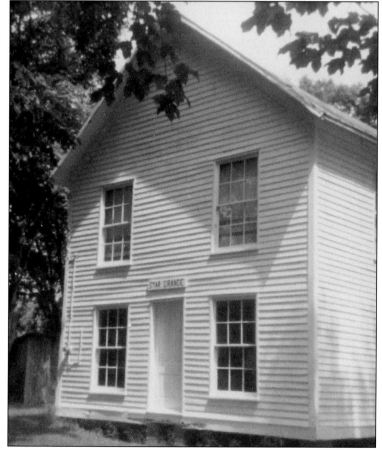

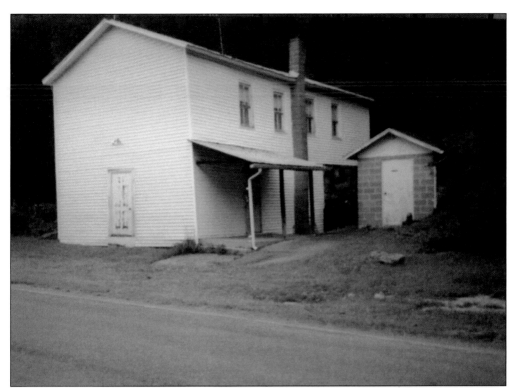

The Modern Woodmen of America Juniper Camp No. 7230, in Burlingham, dates from 1899, and it remodeled this older building as its hall in 1910. Although the MWA seldom does ritualistic work now, it still thrives as an insurance entity. Meigs has another chapter, Alfred No. 10,900, which was chartered in 1902. (Courtesy of Ivan Tribe.)

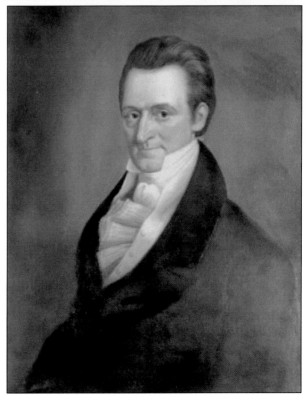

An early resident of Marietta, Return J. Meigs Jr. served in the US Senate and as postmaster general. His major contribution to state and nation, however, was as governor of Ohio from December 1810 to March 1814, which coincided with most of the War of 1812. Whether he ever set foot in the county named for him in 1819 cannot be ascertained, but the chances that he did are greater for Meigs County, Ohio, than for Meigs County, Tennessee, which was named for his father. (Courtesy of Ivan Tribe.)

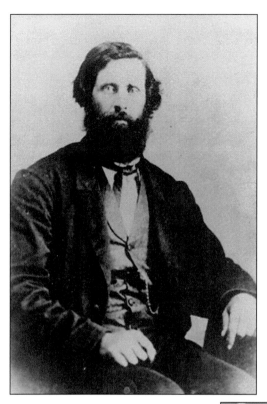

In 1873, Rutland-born physician Brewster Higley wrote the poem "Western Home" while in Smith County, Kansas. It became the lyrics for the Kansas state song, "Home on the Range"—a true classic of popular songs. Higley died in Shawnee, Oklahoma, but a marker in Rutland honors the native son. (Courtesy of Ivan Tribe.)

William H.H. "Tippy Dye" made his name as a basketball coach and collegiate athletic administrator. The Harrisonville native earned all-around athletic honors at Pomeroy High and Ohio State University in baseball, basketball, and football, playing in both the East-West Shrine Game and the College All-Stars versus the Green Bay Packers at the end of his college career. He later coached basketball at Brown University, Ohio State, and the University of Washington. In 1959, Dye became athletic director at Wichita State University and later at the University of Nebraska and Northwestern University. Both he and his wife of 64 years are buried in their native Meigs County. (Courtesy of Meigs County Historical Society.)

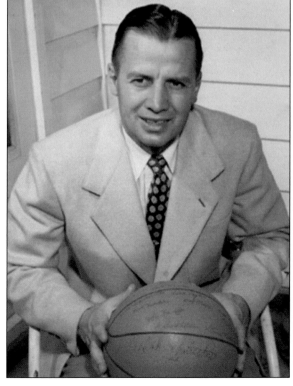

A native of Meadville, Pennsylvania, Tobias Plants taught school and studied law with Edwin Stanton (later Lincoln's secretary of war) before moving to Meigs County, where he became owner of the *Weekly Telegraph*. During that time as a publisher, he served in the Ohio House of Representatives from 1858 to 1862. His two terms in the US Congress (1865–1869) coincided with the era of Radical Reconstruction beliefs. Plants later served as common pleas judge from 1873 to 1875 and as president of the First City Bank of Pomeroy until his death in 1887. (Courtesy of Ivan Tribe.)

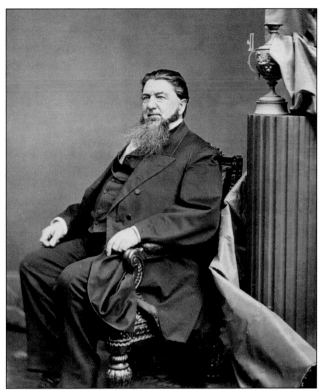

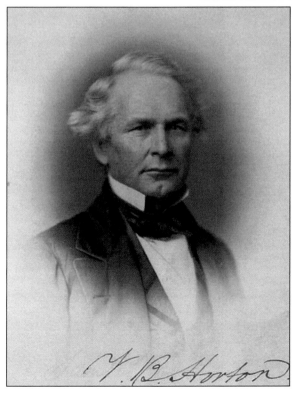

A native of Vermont, Valentine Horton became an attorney, but after coming to Pomeroy in 1835 he engaged in business, where he worked tirelessly to develop the coal and salt industry. A delegate to the Ohio Constitutional Convention in 1850–1851, he served three terms in Congress (1855–1859, 1861–1863) and was an early leader of the Republican Party. His daughter married Union major general John Pope. Once a man of considerable wealth, Horton eventually lost of much of it but continued to live in Pomeroy until his death. (Courtesy of Ivan Tribe.)

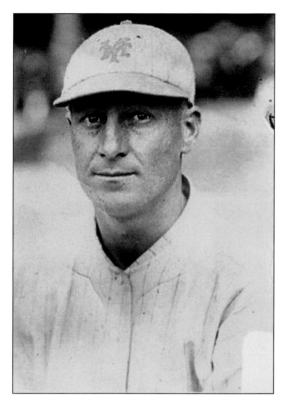

Benjamin Michael Kauff, a Pomeroy native, rose from the obscurity of the Meigs County coal mines to fame on the baseball diamond and ultimately went back to obscurity. He was a two-time batting champion of the short-lived Federal League and also a competent center fielder with the New York Giants from 1916 to 1920. Implicated in an auto theft, he was banned from the sport by baseball commissioner Kenesaw Mountain Landis despite his acquittal in a court trial. He later worked as a baseball scout and for a clothing company. Baseball historian Bill James ranked him 94th among the 100 best center fielders in the history of baseball. (Courtesy of Ivan Tribe.)

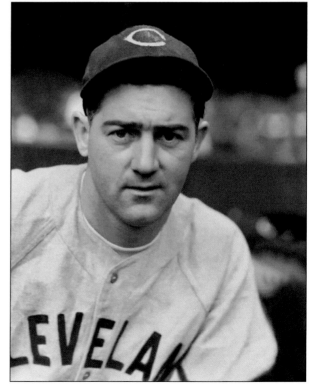

Ralston B. "Rollie" Hemsley, a native of Syracuse, had a long run in baseball, primarily as a catcher, and had a lifetime batting average of .262 in 1,593 games. While he played for several major-league teams, his career highlights were mainly with the St. Louis Browns and the Cleveland Indians, where he was Bob Feller's favorite battery mate. A rollicking playboy in his early years, Hemsley finally reformed and later managed in the minors and became a major-league coach. Of the nine Meigs Countians to play major-league baseball, he was probably the most accomplished, ranked the 69th-best catcher by baseball historian Bill James. (Courtesy Ivan Tribe.)

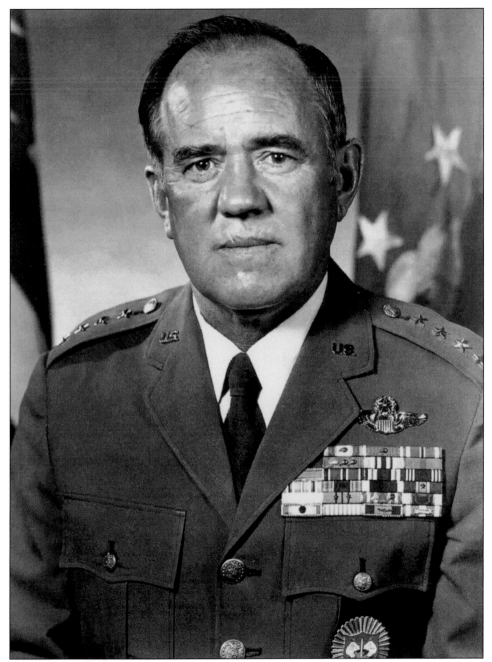

No native Meigs Countian has had a more distinguished military career than Gen. James Hartinger, who eventually earned four stars on his shoulders. He entered the Army in 1943 after graduating from Middleport High School. He served in World War II before moving on to West Point. He graduated from the academy in 1948 and became an Air Force officer. A combat pilot in the Korean War, Hartinger advanced through the ranks by flying 100 combat missions in Vietnam, and then he capped off his career as commander in chief of NORAD. He retired in 1984 and died in Colorado Springs at age 75. A street and park in Middleport honor his memory. (Courtesy of Meigs County Historical Society.)

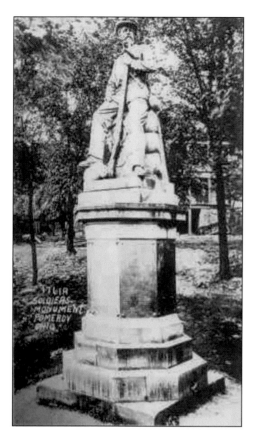

Over 2,200 Meigs Countians served in the Union army in the War Between the States, with over 500 giving their lives. Six of these men earned the Congressional Medal of Honor. The war memorial lists the names of these honored soldiers on the base of the statue. Dedication of the memorial took place on October 17, 1871, before a crowd of some 2,500 citizens. (Courtesy of John Bentley.)

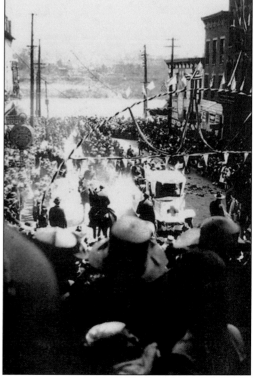

Meigs County troops returned home to a parade when World War I ended on November 11, 1918. Led up Court Street by a World War I ambulance, thousands of Meigs Countians flooded the streets of Pomeroy to welcome home their sons, brothers, and husbands. (Courtesy Jordan Pickens.)

Four

TRANSPORTATION
RIVER AND RAIL

A local writer once referred to Meigs County as the "heart of the valley." Like arteries transporting blood away from the heart, railroads took their coal across the country. Steamboats brought people and goods inward, much like veins bringing blood into the heart. Both of these modes of transportation also provided ample jobs for workers at the Hobson Yards or for boatmen on the river. The automobile age eventually provided the principal means of travel.

Before the coming of steamboats, early pioneers traveled to Meigs downstream in canoes, flatboats, and keelboats—journeying from such locales as Pittsburgh, Redstone, and Wheeling. An early description survives of the legendary Mike Fink shooting the rapids at Letart Falls.

The first steamboat on the Ohio River left Pittsburgh in 1811 with New Orleans as its final destination. Throughout the years, steamboats have graced the banks and locks on Meigs County shores, bringing goods, people, entertainment, and conversation. Steamboats pushing barges full of Meigs County coal have traveled throughout the Mississippi system. Capt. John B. "Alligator Jack" Downing, a Middleport boat pilot, taught Samuel Clemens (Mark Twain) his knowledge of river navigation.

In 1882, two major "veins" entered Meigs with the construction of railroads. These lines not only opened Meigs County markets to the North but also to Columbus and the Great Lakes region for both freight and passengers. The rail line going north passed through four tunnels between Langsville and Carpenter, climbing out of the valley along Leading Creek. Section hands kept the tracks in order, and crews of five men per train kept the iron horses running. Hobson became an important point where train crews changed. In 1901, the Kanawha & Michigan Railroad established Hobson Yards as a place for its roundhouse and car-repair shops. Over the next 50 years, as many as 800 men worked in these shops, stimulating the economy of Middleport and its environs. Although the number of workers fluctuated, they were slowly phased out when diesel power and passenger service ended in the early 1950s.

The automobile age arrived, and slowly but surely road improvements took place. By the late 1950s, most state roads were paved but tended to be crooked and curved. Improvements were slow, but by the dawn of the 21st century much of Route 33 and some of Route 7 within Meigs became four lanes; meanwhile, boats and barges still travel downriver, and the freight trains still rumble through, carrying coal and chemicals north from West Virginia.

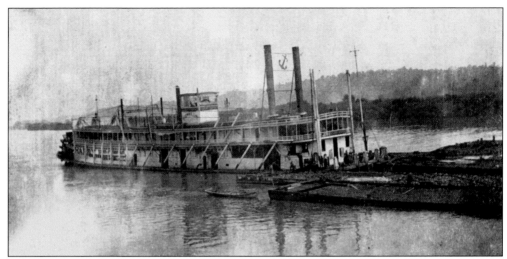

The steamboat *Harry Brown* (above) was built in Pittsburgh, Pennsylvania, in 1879. It was owned by W.H. Brown & Sons and operated on the Ohio and Mississippi Rivers until its boiler exploded below Vicksburg, Mississippi, on May 10, 1896. Eleven crew members died in the blast. Here, she is seen passing Pomeroy. The Belleville Locks and Dam (below) are located at mile marker 203.9 on the Ohio River. Construction began in May 1962 and was completed in October 1965. Belleville replaced locks and dams nos. 17, 18, 19, and 20 on the Ohio River, dam no. 1 on the Muskingum River, and dam no. 1 on the Little Kanawha River. This image of the locks and dam was taken in September 1969 shortly after the pool level was raised to full capacity. (Above, courtesy of Robert Graham; below, courtesy of Meigs County Historical Society.)

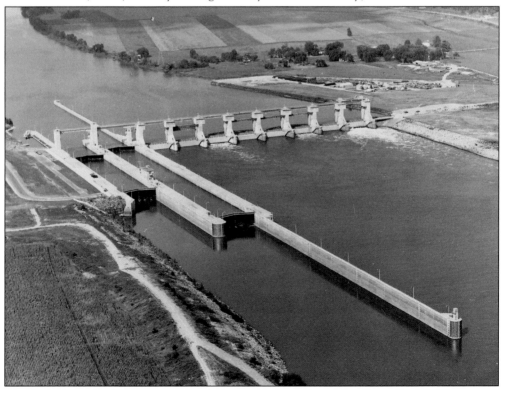

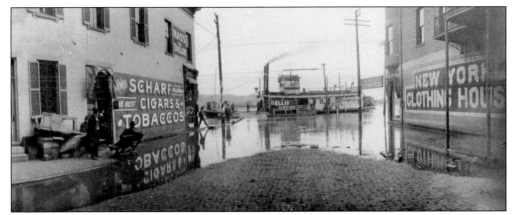

Prior to the Pomeroy Bend Bridge opening to traffic in the late 1920s, residents of Meigs and Mason (West Virginia) Counties traveled back and forth on the ferryboat *Champion No. 3*. The ferry went into service in 1901 under the ownership of J.F. Jividen and his brother Charles. Once the bridge opened, the *Champion No. 3* spent the rest of her days in Proctorville Ohio. She was dismantled in 1935. The ferry is shown here from Lynne Street in Pomeroy during the 1913 flood. (Courtesy of Robert Graham.)

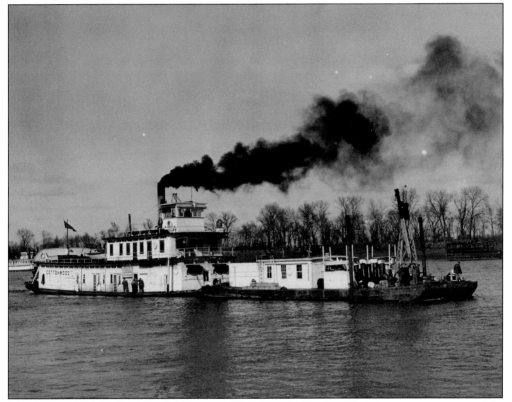

The *Cottonwood*, built in 1915, was originally an Army Corps of Engineers river tug named *Le Claire*. She was acquired by the Lighthouse Service in 1938 and renamed *Cottonwood*. The tug was stationed at St. Louis and then Chattanooga while working for the Coast Guard. *Le Claire* was decommissioned in 1946 and sold the following year. She is shown here in between Syracuse and Racine in 1945. (Courtesy of Meigs County Historical Society.)

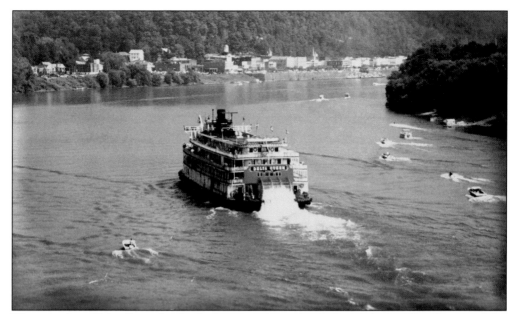

The steamboat *Delta Queen* has had a long-standing relationship with the Ohio River and the people of Meigs County since being brought to Cincinnati, Ohio, by Capt. Gordon C. Greene in 1948. For many summers, the vessel has been seen plying the river during the occasional calliope concert in Pomeroy. Here, the *Delta Queen* is seen making her way into Pomeroy in 1997. (Courtesy of Robert Graham.)

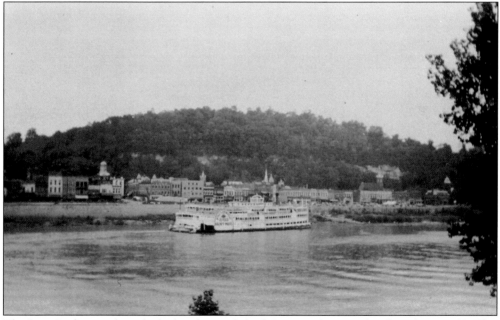

The *Saint Paul* is seen here docked at the newly built Pomeroy levee and parking lot in 1937. This side-wheeler was built in 1883 in St. Louis, Missouri, for the St. Louis & St. Paul Packet Co., running under the Diamond Joe flag. After being rebuilt in 1939 in Paducah, Kentucky, the boat was renamed the *Senator*. *The Saint Paul* was retired from excursion service in 1942. (Courtesy of Robert Graham.)

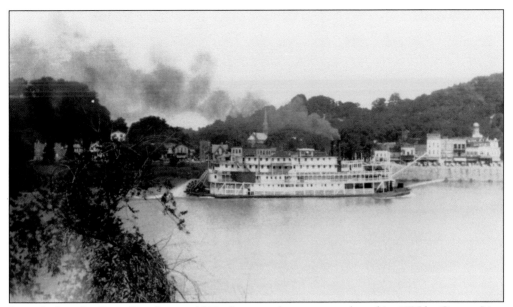

Launched as the *Cape Girardeau* in 1923, this steamboat was purchased in 1935 by Greene Line Steamers of Cincinnati and named *Gordon C. Greene* for its founder. The boat is shown coming into Pomeroy. She ran excursions primarily between Cincinnati and Pittsburgh between 1935 and 1952 before being sold and renamed the *Sara Lee* and later the *River Queen*. She sank on December 3, 1967, in St. Louis, Missouri. (Courtesy of Robert Graham.)

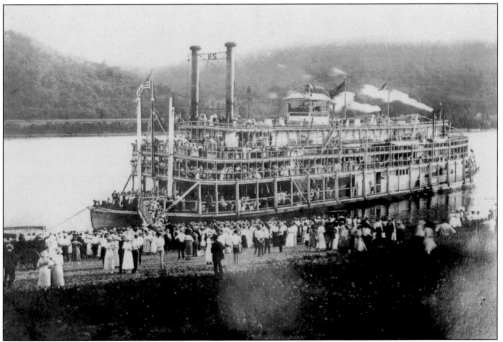

Built in 1914 in Jeffersonville, Indiana, the *Homer Smith* was based out of Point Pleasant, West Virginia, with the Security Steamboat Company. The steamboat would take yearly Mardi Gras cruises from Pomeroy to New Orleans, Louisiana, until it caught fire in 1931. (Courtesy Robert Graham.)

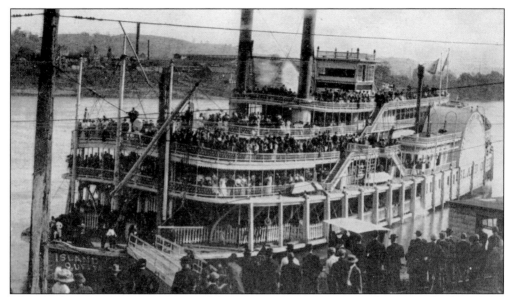

The *Island Queen* was an attraction of the Cincinnati amusement park Coney Island. Put into service in 1896, the boat had a capacity of 3,000 passengers. The *Island Queen* is shown here at the Pomeroy wharf around 1919 loading passengers for an afternoon on the Ohio River. The boat caught fire on the Cincinnati riverfront in 1924. (Courtesy of Robert Graham.)

The Ravenswood Ferry operated for many decades between Great Bend and Ravenswood, West Virginia. The first license to operate a ferry at this locale was granted in 1841. The ferry pictured here terminated service in the 1980s when the William S. Ritchie Jr. Bridge was built. (Courtesy of Jordan Pickens.)

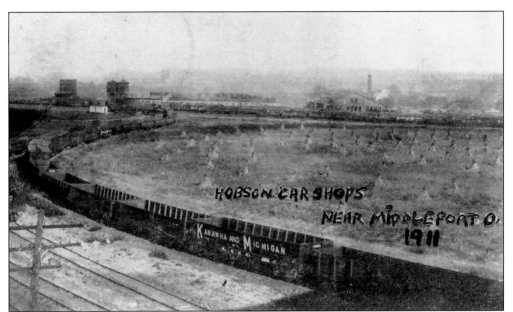

Just below Middleport, Hobson became a major railroad center where train crews changed. Starting in 1902, the nearby Hobson Yards had a roundhouse, car shops, and an icehouse that apparently employed as many as 800 workers at times. It would seem a likely conclusion that this many people worked on train crews and as telegraphers and section hands on the line between Charleston and Corning. Hobson declined with the demise of passenger service in 1950 and the switch from steam power to diesel power in 1953. (Above, courtesy of John Bentley; right, courtesy of Ivan Tribe.)

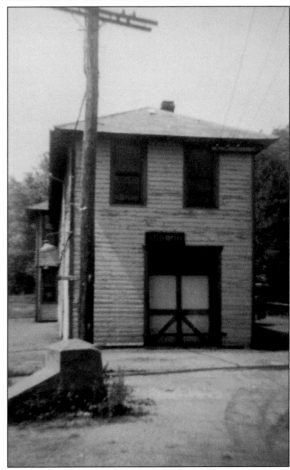

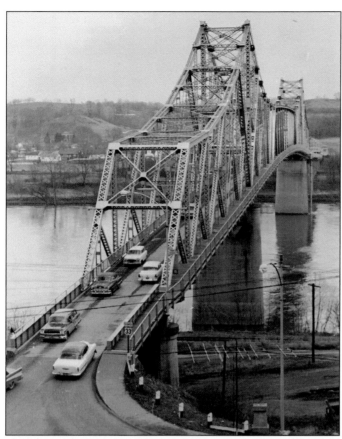

Built in the late 1920s, the Pomeroy Bend Bridge replaced ferry operations in Pomeroy and Middleport with a two-lane span. After the tollbooth was removed, the name was changed to the Pomeroy-Mason Bridge to reflect the two towns it connected. It was demolished in 2009. (Courtesy of Jordan Pickens.)

The Bridge of Honor was built to replace the Pomeroy-Mason Bridge. Ohio governor Bob Taft broke ground in March 2003, and the bridge was opened to traffic in January 2009. This bridge is unique because of the use of black lights to illuminate the cables. (Courtesy of Charlie Mankin.)

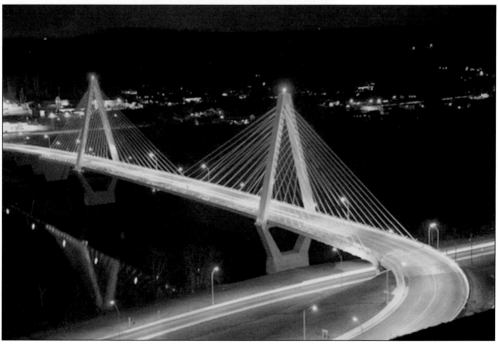

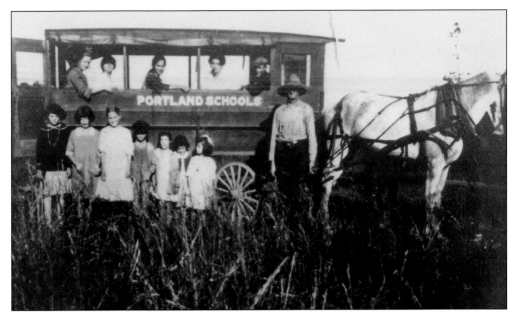

In the early days of public pupil transportation, students were often brought to school via horse-drawn bus. This 1921 photograph demonstrates one such operation in Lebanon Township, with horse, driver, and children all posing for the ride to Portland. (Courtesy of Meigs County Historical Society.)

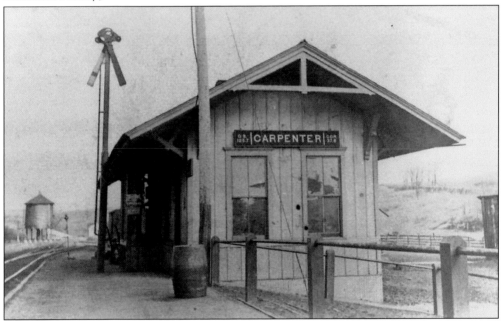

Carpenter was an important spot on the Kanawha & Michigan (later the New York Central) Railroad. A station in Carpenter open 24 hours, seven days a week, also had a water tower and a "helper engine" locomotive to help push heavily laden steam-powered freights up the steep grade between Carpenter and Albany. The switch from steam to diesel locomotives in 1953, with trains speeding past and no longer stopping, spelled the end of Carpenter as a rail station. (Courtesy of Meigs County Historical Society.)

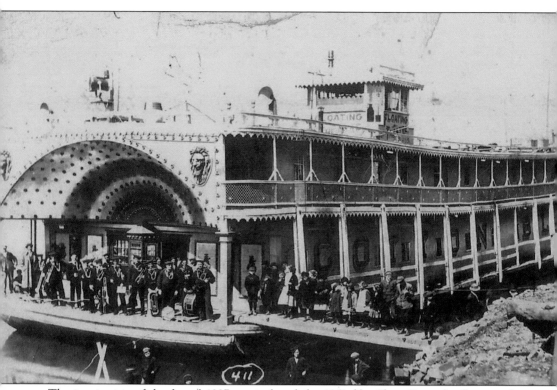

The inspiration of the famed 1927 musical and the 1951 film *Show Boat*, the floating theater *Cotton Blossom* pays a visit to entertain the people of Meigs and Mason Counties. Here, the band and performers pause before taking to the streets of Pomeroy for a parade announcing their arrival and four days of vaudeville-type shows. (Courtesy of Meigs County Historical Society.)

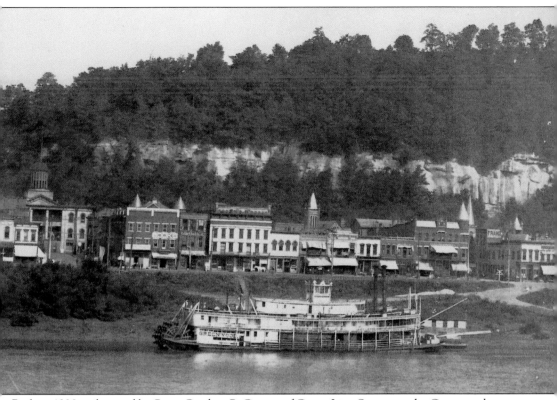

Built in 1898 and owned by Capt. Gordon C. Greene of Green Line Steamers, the *Greenwood* was based in Cincinnati, Ohio, and ran excursions between Cincinnati, Pomeroy, and Charleston, West Virginia. On November 17, 1925, the steamboat *Chris Greene* ran into and destroyed the *Greenwood*. (Courtesy of Robert Graham.)

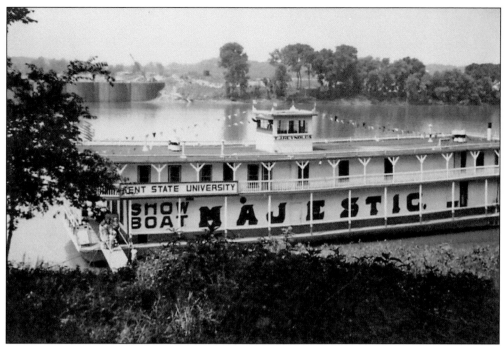

Built in 1923, the showboat *Majestic* and the steamboat *Atta Boy* visit Racine in the early 1960s. The *Majestic* was declared a National Historic Landmark in December 1989 and still offers shows at the Cincinnati waterfront. (Courtesy of Robert Graham.)

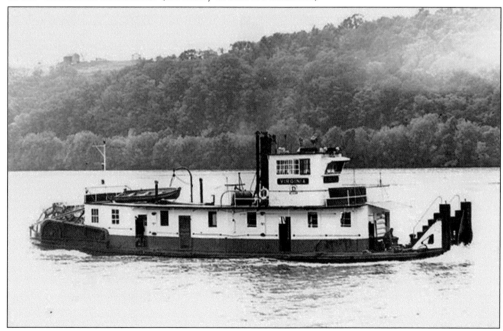

The diesel stern-wheeler *Virginia* was built in 1922 by the Dravo Contracting Co. at Neville Island in Pennsylvania. Originally used to push coal, the *Virginia* spent her later years as a pleasure boat owned by Jim and Mary Donna Davis of Minersville. Unfortunately, in January 2001 the stern-wheeler sank and was later scrapped. (Courtesy of Jordan Pickens.)

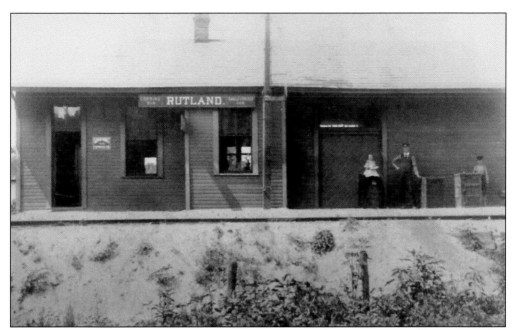

Passengers on the Kanawha & Michigan line would see this view of the Rutland Depot from their windows. The last passenger train pulled out on June 2, 1951. Built at the edge of town about 1886, this station later became a private residence until it was torn down in 2001. (Courtesy of Meigs County Historical Society.)

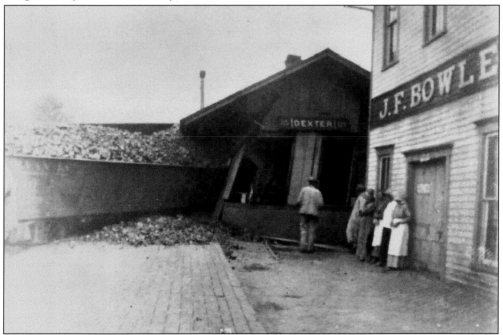

Several train wrecks took place in the Dexter-Dyesville area. This one wrecked the depot. As a result, another station at Moxahala in Perry County was dismantled and rebuilt at Dexter. Note how the coal car that struck the station almost crashed into the J.F. Bowles store nearby. (Courtesy of Meigs County Historical Society.)

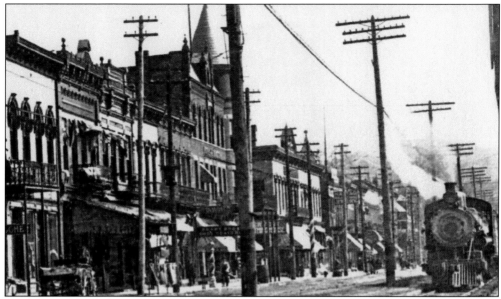

The Ohio and West Virginia Railway extended its line northward from Gallipolis to Pomeroy in the late months of 1880, opening rail service to Pomeroy on January 1, 1881. The freight line later known as the Hocking Valley made its last run to Pomeroy on July 7, 1979. (Courtesy of Meigs County Historical Society.)

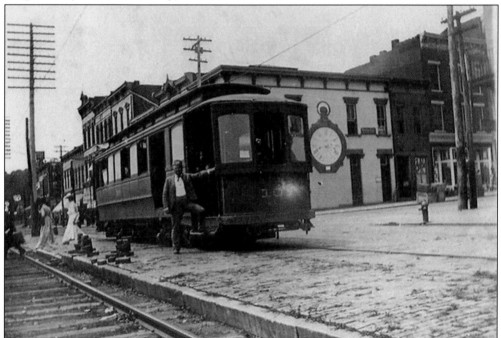

From 1900 to 1929, streetcars were the means of transportation for many Meigs Countians. Electric trolley lines ran from the Hobson Train Depot, up Second Avenue in Middleport, and through Pomeroy, Syracuse, and Racine. Fares varied from 5¢ to 14¢ depending on the length of the trip. Cars were housed in a building, which still stands, between the former Midwest Steel plant and Pomeroy Village Hall. (Courtesy of Jordan Pickens.)

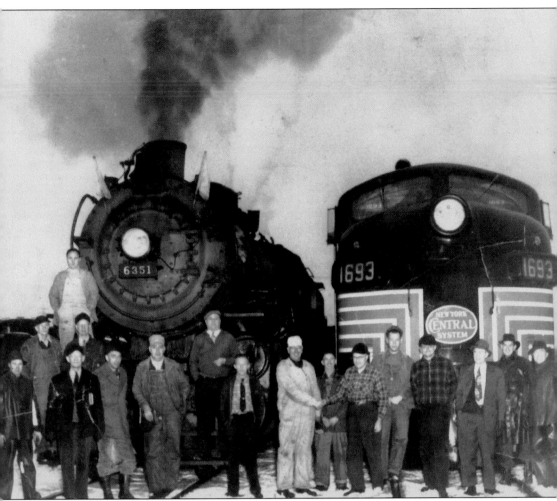

It was a joyous occasion when a diesel locomotive replaced a steam locomotive at Hobson Yards on the New York Central Railroad (formerly Kanawha & Michigan) in the early 1950s. The happiness would be short-lived though, as employee layoffs soon began and continued until few remained at the depot, junction, or yards. By 1969, only five employees remained at the yards. Little remains today at the current Norfolk Southern–owned locale. (Courtesy of Meigs County Historical Society.)

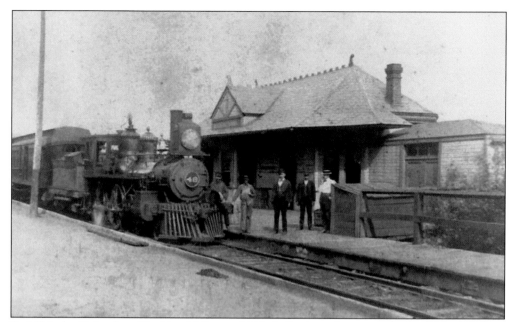

By 1894, the Columbus, Hocking Valley and Toledo Railway (successor to the Ohio and West Virginia) had been in existence for 13 years. It became the longest-lived railroad company operating totally in the state of Ohio. Later, its successor, the Chesapeake and Ohio Railway, ended passenger service on December 31, 1949. (Courtesy of Meigs County Historical Society.)

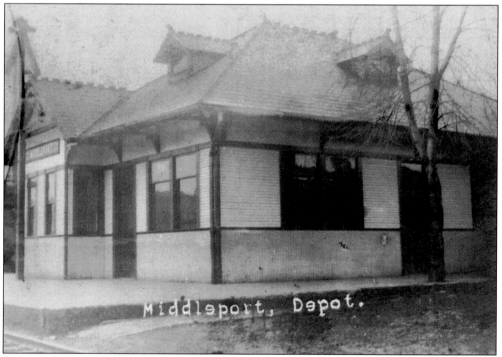

The Middleport Train Station served both the Kanawha & Michigan and Hocking Valley lines. The depot closed in 1953. The remaining part of the building was restored in Dave Diles Park and is used in various Middleport festivals and events. (Courtesy of Meigs County Historical Society.)

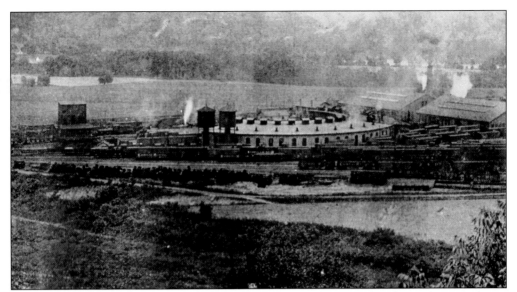

From 1901 to 1953, the roundhouse of the Kanawha & Michigan Railroad at Hobson Yards was the busiest work locale in the county. As many as 800 men in two shifts operated the telegraph keys and repaired and serviced locomotives and railroad cars. (Courtesy of Robert Graham.)

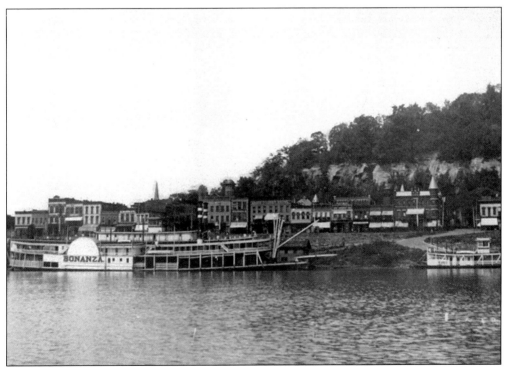

The steamboat *Bonanza* made regular trips to Pomeroy in the early 1900s. The Cincinnati, Portsmouth, Big Sandy, and Pomeroy Packet Company steamboat brought goods and people to Meigs County for many years. Other boats used the area as a stop due to its location as the middle port between Cincinnati and Pittsburgh. (Courtesy of Jordan Pickens.)

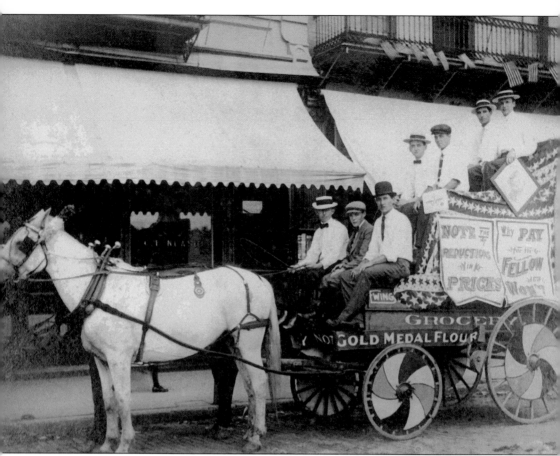

Although in recent decades the Ewing family of Pomeroy became best known for their funeral home, an earlier generation of Ewings was in the grocery business. In former days, grocers often had delivery wagons that took provisions to residences and sometimes peddled their wares door to door. (Courtesy of Robert Graham.)

Five

FLOODS AND OTHER TRAGEDIES
MEIGS COUNTY'S UPS AND DOWNS

Anyone who has lived along the river in Meigs County knows the true beauty and majesty that it offers. The term *potamophilous* means "loving or having an affinity towards rivers." Yet with this beauty also comes the rage. The sheer strength of the Ohio River during various floods has destroyed businesses, homes, and lives. Thankfully, with the modernization of the dam system, the river is more restricted. Instead of the yearly flood making its way into the second stories of Pomeroy businesses as it did in the early half of the 20th century, the river now visits Meigs County's river towns once or twice a decade.

The flood stages for the area are as follows:
41 feet—State Route 124 at Antiquity begins to flood;
42 feet— State Route 124 at Minersville begins to flood;
46 feet—The parking lot, the amphitheater, and Main Street in Pomeroy, as well as various back roads in the county, start to flood;
48 feet—The village of Racine and businesses on Main Street in Pomeroy start to flood;
52 feet—All of the businesses on Main Street in Pomeroy are now flooded; the London Pool, as well as State Route 124 in Syracuse, begins to flood;
58 feet—The courthouse begins to flood.

Meigs County is one of the few counties along the Ohio River where a village or community does not feature a flood wall. While the flood wall would better protect businesses and homes along the river, many Meigs Countians are appalled at the thought, arguing that a periodic flood is the cost of the breathtaking views of the Ohio River.

Fires, rockslides, twisters, and super storms have also affected Meigs County. Through the willingness of the volunteer fire departments, police, and emergency medical services, local residents and merchants are more at ease knowing in the event of such devastation dozens of men and women are willing to put their lives on the line to protect the general public. No matter what devastation may occur, Meigs Countians come together and help one another in times of need.

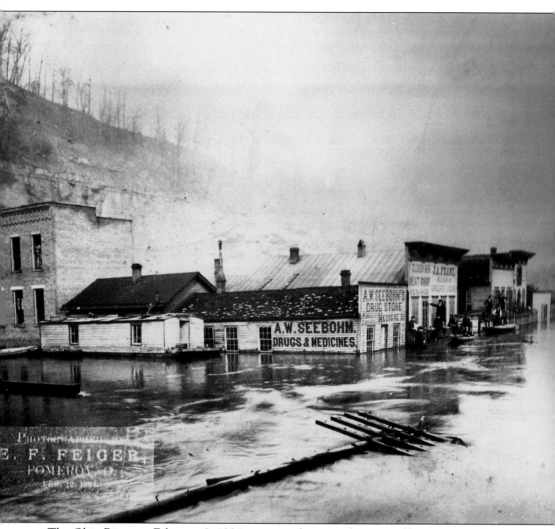

The Ohio River on February 9, 1884, crept to the second stories of businesses in Pomeroy as floodwaters reached 56.5 feet. A.W. Seebohm Drugs & Medicines, Gloeckner Meat & Ice, and J.A. Franz groceries are inundated as an electric pole floats down Main Street. (Courtesy of Meigs County Historical Society.)

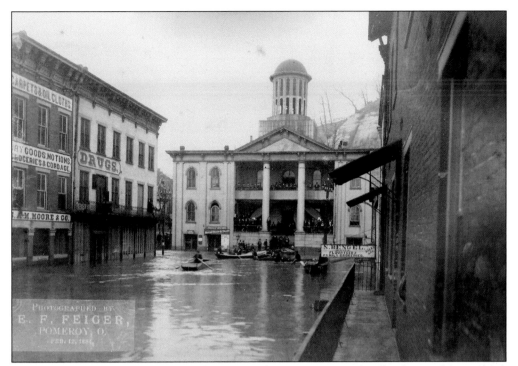

Spectators line the porch of the courthouse on February 12, 1884, after floodwaters have crested. Men in skiffs row to their businesses to check on damages as spectators converse at the courthouse and prepare for the cleanup. (Courtesy of Meigs County Historical Society.)

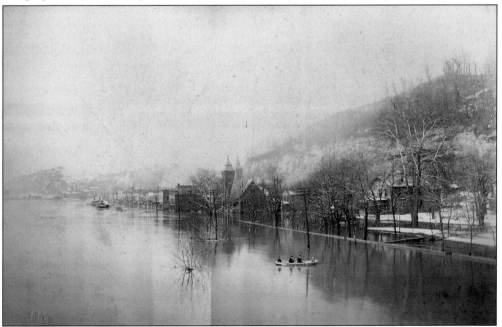

Snow mixes with the chilly waters of the Ohio River in the flood of 1884, the third-highest flood on record in Meigs County. The Pomeroy wharf boat, the depot, and several businesses can be seen as floodwaters rise. (Courtesy of Jordan Pickens.)

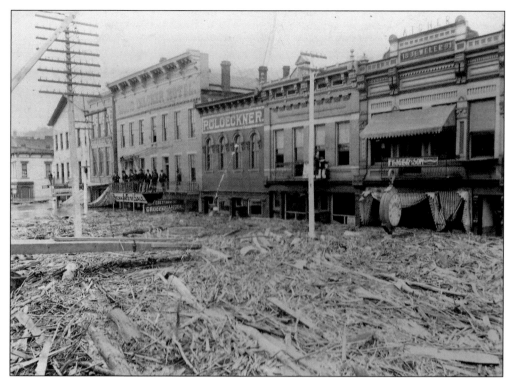

In March 1898, the final big flood of the 19th century hit Meigs County, bringing with it tons of Ohio River driftwood. On Main Street in Pomeroy, Schlagel's store, the Grand Dilcher Hotel, Gloeckner Saloon, and Atcher Jewelry wait out the mess. (Courtesy of Meigs County Historical Society.)

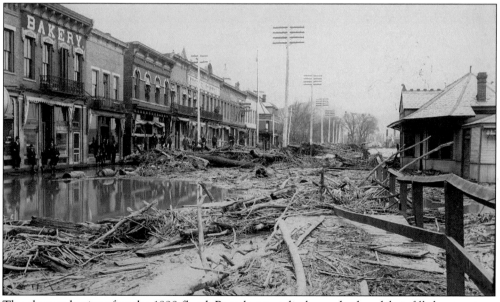

The cleanup begins after the 1898 flood. Barrels, trees, limbs, and other debris fill the streets as the water level slowly recedes to the banks of the Ohio River. Notice the steamboat at street level in the distance behind the telegraph office. (Courtesy of John Bentley.)

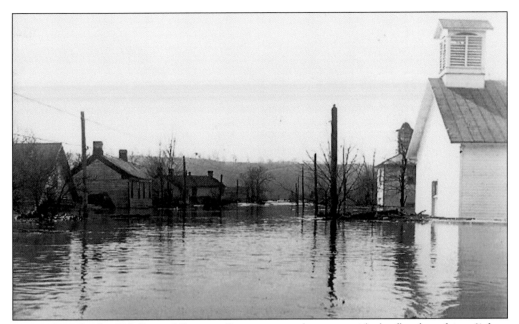

Pictured in March 1907, Second Street in Syracuse is underwater, with the flood reaching 61 feet. To the right stand the Presbyterian church and the former Syracuse Village hall, both of which are used today as churches. The first and the third houses on the left still stand and are occupied today as well. (Courtesy of Jordan Pickens.)

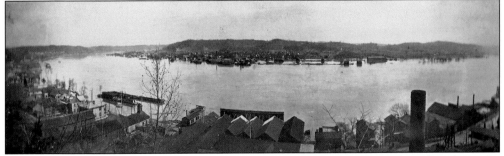

This bird's-eye view of the Pomeroy bend during the flood of 1910 shows the saltworks in the foreground, with Ebersbach Boat Yards to the left. The Ohio River rose about 30 feet in March of that year, but it did very little damage to the county. (Courtesy of Meigs County Historical Society.)

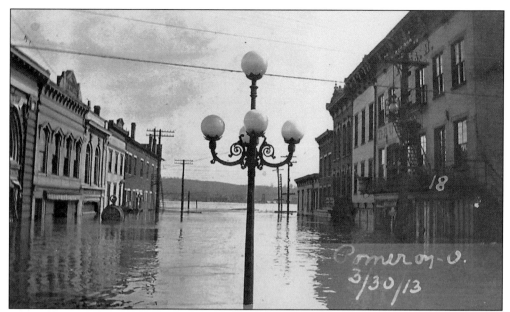

The highest recorded flood to hit Meigs County was in late March 1913. It came with hurricane-force winds, blizzards, and tornadoes. Two to three months worth of rain fell from March 23 through March 27. Every river in the state of Ohio overflowed its banks. Here, the lamppost stands alone in front of the courthouse, one day after the river crested. (Courtesy of Meigs County Historical Society.)

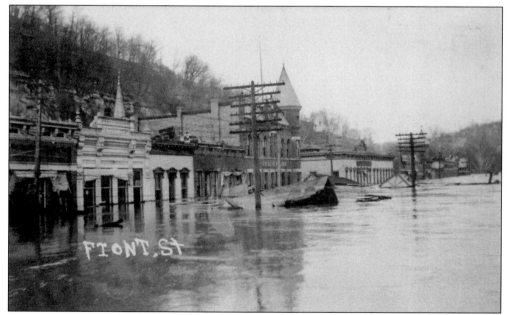

Anything imaginable was seen floating down the Ohio River in the 1913 flood. Here, the rooftops of houses and buildings are wedged against electric poles on Main Street in Pomeroy. Floodwaters made their way into the second stories of the buildings once again. (Courtesy of Robert Graham.)

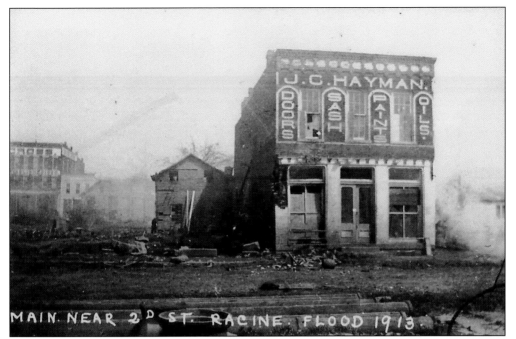

Floodwaters have subsided, and cleanup begins in Racine after the flood of 1913. J.C. Hayman's Hardware store on Main Street, which sold doors, sashes, paints, and oils, suffered severe merchandise loss as well as damage to the building; it went out of business shortly thereafter. (Courtesy of Meigs County Historical Society.)

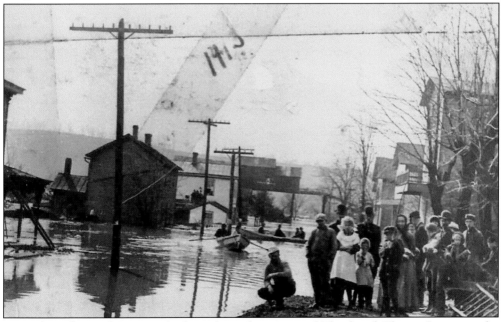

Several residents of Syracuse look on from the corner of Third and Cherry Streets at the damage to houses and businesses on Second and Water Streets, which are mostly underwater. Men are using skiffs to rescue families stranded in the floodwaters. (Courtesy of Meigs County Historical Society.)

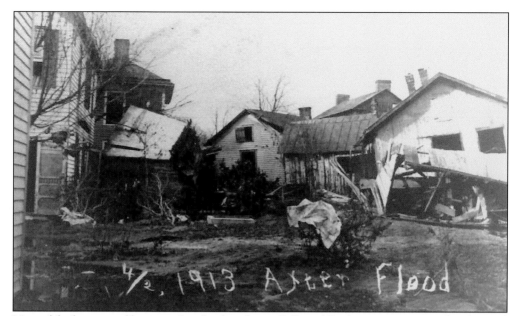

Most of the houses and barns on farmlands in Letart Falls and Bucktown were a complete loss and had to be demolished after the flood of 1913. Several sheds and barns collided into the sides of several homes, which also had to be demolished. (Courtesy of Meigs County Historical Society.)

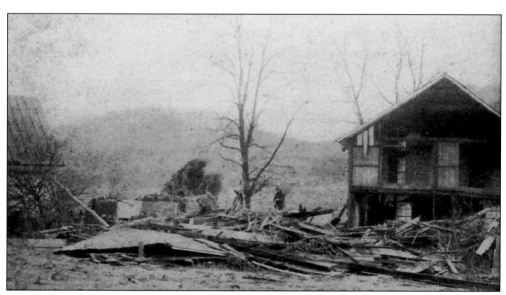

Taking the good with the bad of living along the river, this resident of Middleport has lost everything, including her home, in the 1913 flood. While one half of the house is left standing, the other lies in ruin. (Courtesy of Meigs County Historical Society.)

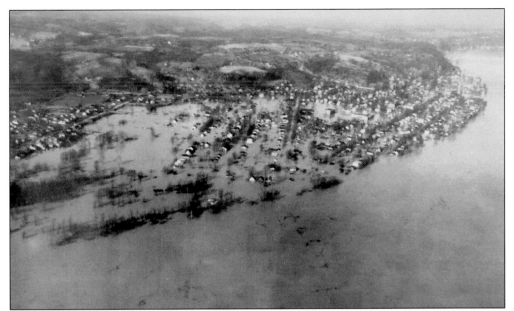

The flood of 1937 crested at 67 feet on January 26. With the country in the midst of the Great Depression, what most people did not lose because of economic woes was taken in that flood. Middleport (above) and Pomeroy (below) are shown as floodwaters invade the villages on the day of the historic crest. (Both, courtesy of Robert Graham.)

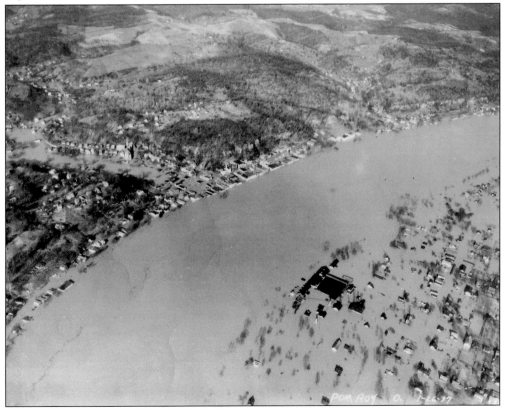

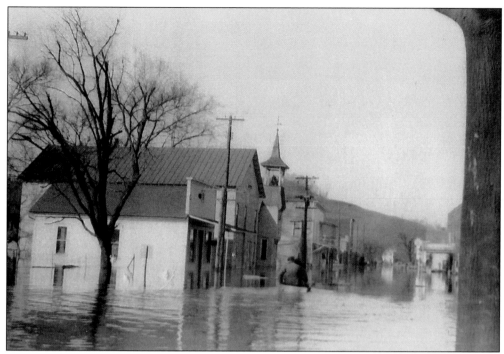

Even Meigs County's only village not located along the river felt the hardship of the flood of 1937. Rutland's Leading Creek, which empties into the Ohio River at Middleport, flooded Main Street, along with other parts of the village. (Courtesy of Robert Graham.)

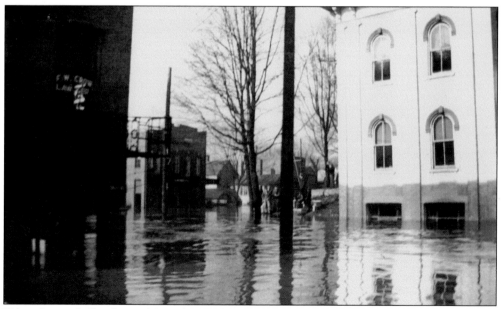

Taken from a skiff in front of Goessler Jewelry on Court Street opposite the F.W. Crow law office, this photograph shows the high water mark from the river that washed away the white paint and submerged the first story of the courthouse. (Courtesy of Robert Graham.)

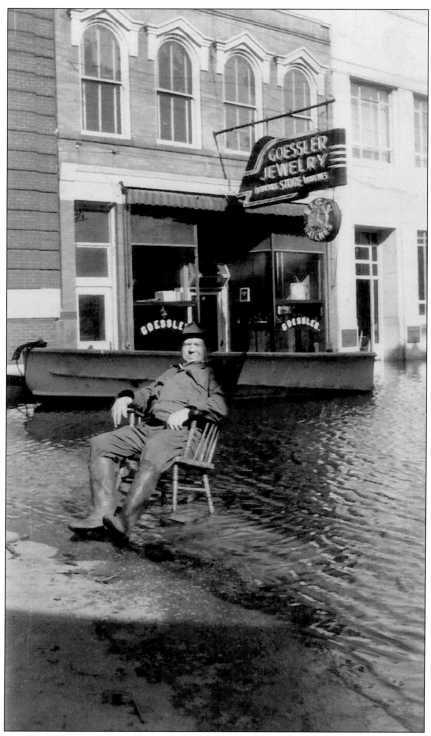

Meigs County native Frank Harold donned his boots and brought a rocking chair to Court Street as the Ohio River rose in 1937. He said, "If the river comes up any higher, I'm going to drink the damn thing dry." (Courtesy of Meigs County Historical Society.)

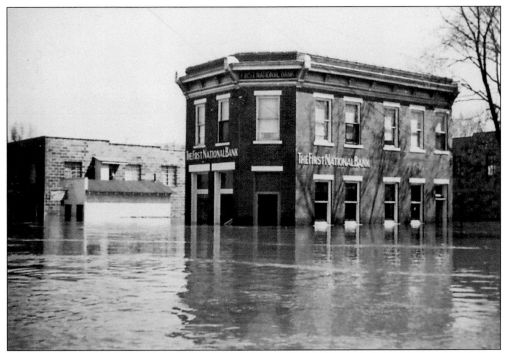

This is the First National Bank of Racine, which would later merge with Racine Home Bank to become the Racine Home National Bank. The building, located on Third Street, suffered little damage in the flood of 1937 due to it being constructed of brick and the fact it was six feet above ground level. (Courtesy of Robert Graham.)

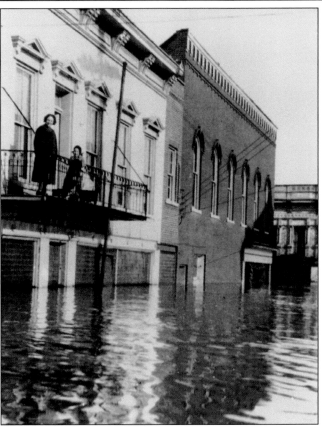

A mother and daughter take in the view from their balcony above a business in Middleport in 1937. A skiff passing by pleaded with the two to get in the boat and to reach safety, but they were perfectly content to stay at home and wait the flood out. (Courtesy of the *Daily Sentinel*.)

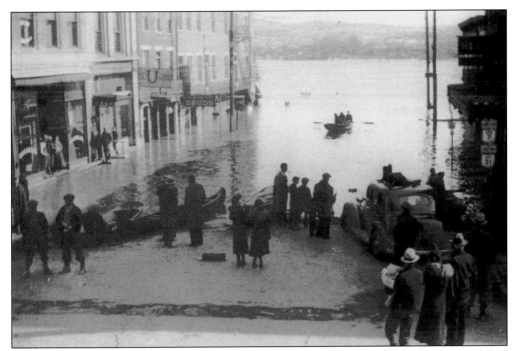

Locals in Pomeroy have just rescued a stranded tenant of an apartment above a business on Main Street in Pomeroy during the flood of 1940. That flood reached 48 feet on April 22. (Courtesy of Robert Graham.)

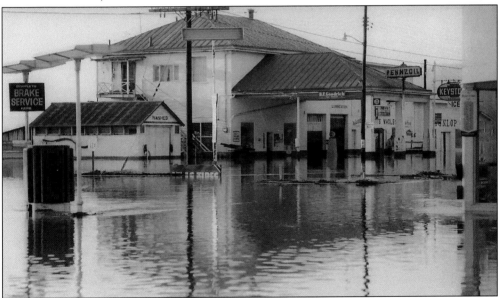

The flood of January 1959 forced 49,000 people from their homes across the state, when three to six inches of rain fell on snow-covered frozen ground. The rain mixed with the melting snow and pushed the Ohio River over its banks. With the modernization of the dam systems, as well as reservoirs, this event was not as intense as the 1913 or 1937 floods, but it still took the lives of 16 people. Vista service station in Racine along State Route 124 is seen submerged in the icy floodwaters. (Courtesy of Robert Graham.)

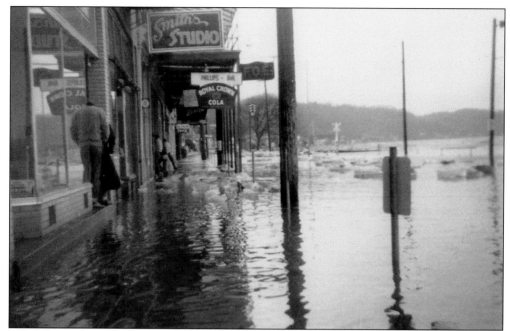

Meigs County patrons of Rivervue Restaurant, Ben Franklin five-and-dime store, Smith's Studio, Phillip's Bar, and the Fraternal Order of Eagles on Main Street in Pomeroy had to wade through the icy floodwaters of 1959. The river reached 43.6 feet on January 24. (Courtesy of Mary Grace Stobart Cowdery.)

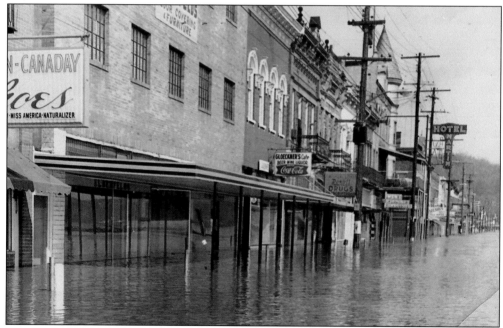

The flood of 1979 crested at 51.8 feet on February 28. When the waters receded, Meigs County salt was drawn out of the abandoned mines, leaving three inches on the streets of Pomeroy to be cleaned up. Here, Elberfeld's, Gloeckner's Cafe, and Swisher & Lohse Pharmacy get their visit from the river every few years or so. (Courtesy of Meigs County Historical Society.)

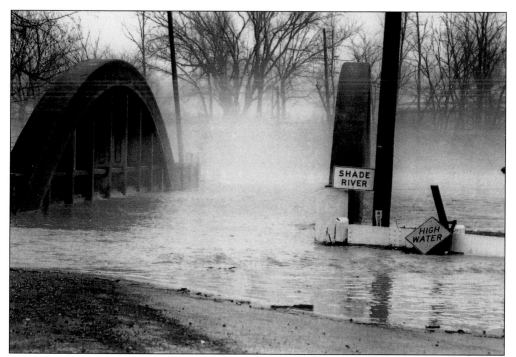

Residents of Meigs County's interior communities are no strangers to flash flooding. The Shade River, located primarily in Chester Township and smaller than the Ohio River, is known for periodic flash floods that have left houses along its banks in shambles. Here, the Shade River Bridge on State Route 248 becomes impassable due to high water. (Courtesy of Robert Graham.)

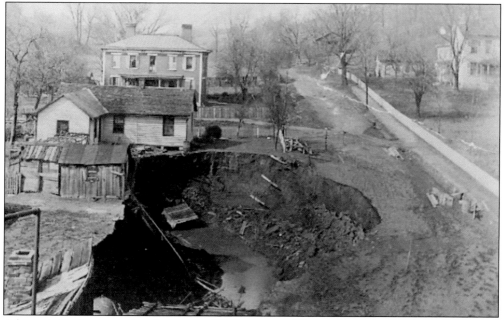

A large sinkhole occurred at the corner of Bridgeman and Fourth Streets in Syracuse just after the turn of the 20th century. Thankfully, no one was injured, and no houses perished in the collapse. These three structures stand today and are still used as homes. (Courtesy of Jordan Pickens.)

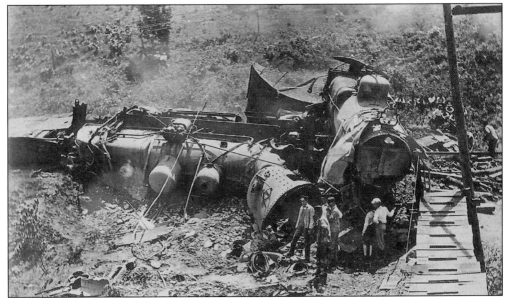

On June 23, 1911, a passenger locomotive and light engine crashed near Dyesville, killing two persons and injuring four. Rail accidents like this inspired the last line of the famous song "The Wreck of the Old '97": "Never speak harsh words to your true loving husband, he may leave you and never return." (Courtesy of Robert Graham.)

Early Sunday morning on June 15, 1986, the Meigs Inn on Main Street in Pomeroy caught fire. Originally constructed as the Remington House, this iconic building also hosted the City Loan Bank and the New York Clothing House. Over 10 fire departments from the area extinguished the flames. (Courtesy of Meigs County Historical Society.)

In February 1966, shortly after 10:30 p.m., the First National Bank in Racine caught fire because of an electrical shortage to a light fixture. The Racine Volunteer Fire Department, along with Syracuse Volunteer Fire Department and others, extinguished the fire that claimed the life of Edith Dunfee. (Courtesy of Charlie Pyles.)

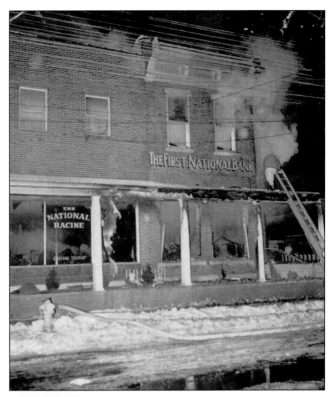

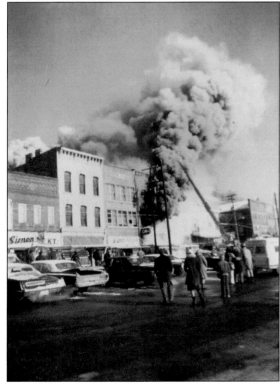

On January 28, 1976, several fire departments were alerted to a fire on Main Street in Pomeroy. Temperatures were so cold that day that water froze right after it came out of the hoses. Three buildings were lost in the blaze and later demolished. (Courtesy of Eber Pickens Jr.)

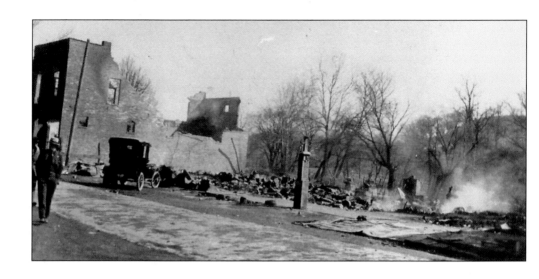

In 1926, a fire broke out inside Rathburn's Department Store in Rutland that destroyed every structure on the block, including Rathburn's and Snowden's Grocery. Temporary establishments were set up inside the former Powers Hotel building until Rathburn's and Snowden's were rebuilt. (Above, courtesy of Jordan Pickens; below, courtesy of Robert Graham.)

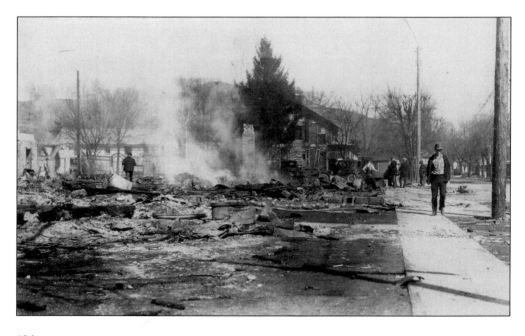

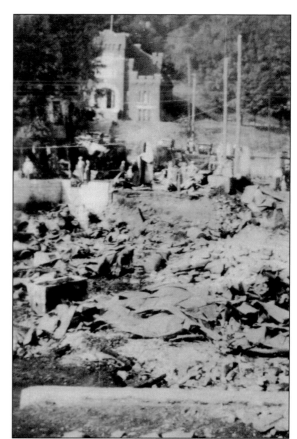

In the summer of 1927, two blocks of Pomeroy businesses were leveled by fire. The blaze began in the livery stable between Second and Mechanic Streets and spread rapidly, destroying 18 businesses and causing over $200,000 in damages. (Both, courtesy of Eber Pickens Jr.)

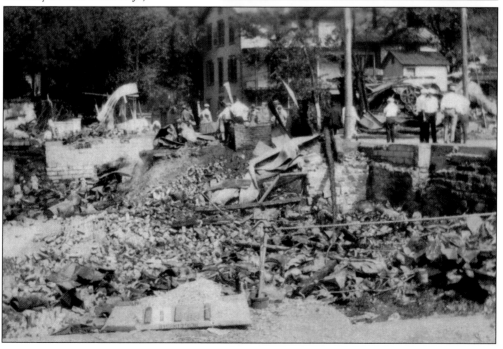

DISCOVER THOUSANDS OF LOCAL HISTORY BOOKS
FEATURING MILLIONS OF VINTAGE IMAGES

Arcadia Publishing, the leading local history publisher in the United States, is committed to making history accessible and meaningful through publishing books that celebrate and preserve the heritage of America's people and places.

Find more books like this at
www.arcadiapublishing.com

Search for your hometown history, your old stomping grounds, and even your favorite sports team.